BLACK AMERICA SERIES
HERNANDO COUNTY
FLORIDA

On the Front Cover: Pictured from left to right are Mark Thompson, John Floyd, William Wright Jr., Clarence Walker, and Alfred Brown, all veterans and members of the Frederick Kelly Elks Lodge #1270 in Brooksville, Florida. Thompson was a family man and superintendant of Sunday school at his church. Floyd was the principal at Moton High School until it closed in 1968. He was a church deacon and served as exalted ruler of the Lodge for 18 years. Wright was active in church and a youth advocate. Walker, who was active in church and taught school, unsuccessfully ran for a seat on the Board of County Commissioners.

On the Back Cover: This photograph shows an Allen Temple African Methodist Episcopal Church group (see page 42).

BLACK AMERICA SERIES

HERNANDO COUNTY
FLORIDA

Imani D. Asukile

Copyright © 2005 by Imani D. Asukile
ISBN 0-7385-4186-9

Published by Arcadia Publishing
Charleston SC, Chicago IL, Portsmouth NH, San Francisco CA

Printed in Great Britain

Library of Congress Catalog Card Number: 2005931091

For all general information contact Arcadia Publishing at:
Telephone 843-853-2070
Fax 843-853-0044
E-mail sales@arcadiapublishing.com
For customer service and orders:
Toll-Free 1-888-313-2665

Visit us on the internet at http://www.arcadiapublishing.com

CONTENTS

ACKNOWLEDGMENTS

This book is dedicated to my oldest sister and college roommate, Mary Anne Bennett, who died in 2004. She utilized her librarianship skills to fine-tune my appreciation for the arts, literature, poetry, music, history, and much more. We talked several hours a week about these topics. Mary Anne provided my room and board during undergraduate and most of graduate school. Most importantly, she gave me an opportunity to live in post–Martin Luther King Jr. Atlanta in the early 1970s, when it was emerging as one of America's next great cities and a land of opportunities for blacks. Because of her generosity, I had the good fortune to meet many of the great black American leaders and study with some of the most progressive thinkers of the last 50 years. For that, I am forever thankful to Mary Anne.

It is not possible to name everyone who contributed to this project. However, it would not have been possible without people like Sarah Stewart and Naomi Walker, who immediately opened their entire photograph collections to me to assist with this project. Beatrice Collins (may peace be upon her soul) did not live to see the project completed, but she gave me all the encouragement that I would need before she passed. She was marketing the book when it was just a subject of discussion.

Mae Alice Ingram was invaluable to the success of this project. I did not know her as child and would not have recognized her if I saw her walking on the street before our discussions on her porch. However, as soon as I explained to her what I was doing, she provided me with some jewels of photos to share with the readers, and I am grateful to her also. To Sillar Lawson, Gwendolyn Hardin, Hazel Land, Carrie Martin, Rosetta Perry, Virgil Thomas Jr., Eloise Wright, Henry Wright, the late Beverly Inmon, Ophelia and Kelvin Brown, Pearline Drake, and so many more, I say "thank you."

I would like to thank Rev. James "Jim" McRae for mentoring me and for his encouragement. I consider him to be one of Hernando County's great achievers. Willie Stephens planted many seeds in my mind about history during his student internship in my civic class in 1968 and during our many conversations as my Neighborhood Youth Corps (summer youth employment program) counselor. Lorenzo Hamilton also gave me an opportunity to cultivate my leadership skills working in the various programs at Kennedy Park. All that I learned from these men assisted me with this book.

I must thank Pasco-Hernando Community College for granting me a sabbatical to take time off from work in 1994 to pursue writing a narrative history of blacks in the county. The research that was done on that project was beneficial to this. I thank Shaquandra Howell and Molly Riney for their assistance. I am saddened that my good friend and protégé Felisha Barker did not live to see this project through to completion. She edited my proposal. Michael Cook assisted with the military section of the book

I would like to thank all of the individuals who contributed to the project in some way. The Heritage Museum, the Oldtime Roundtable, the African American Heritage Society of East Pasco County, the East Pasco Heritage Society, and the Moton High School Reunion Committee have fostered my interest in this project.

Finally I would like to thank my wife, Angela, for all her assistance with the project. She is detail-oriented and wants everything to be right. She did not give up on the project during the darkest moments, and she would not let me give in, out, or up. My children allowed me to neglect them while I was trying to finish the book. On occasion, they helped, too. I must thank Barbie Langston Halaby of Arcadia Publishing and my editor, Kathryn Korfonta, for patiently walking me through the process.

INTRODUCTION

Black America Series: *Hernando County* is the culmination of many citizens' dreams, hopes, and prayers. The book documents parts of the history of blacks in the county from the mid-1800s to the present. The Black America Series also freezes faces and places in an effort to preserve them for others to use. Future writers and generations will not have to search as hard for the links to their past. The reader can examine the pain, agony, joy, pride, and dignity of blacks who built a community under diverse circumstances such as slavery, the Great Migration, Reconstruction, the Great Depression, wars, Jim Crow, and other challenges. If nothing else, the book provides reference points for readers about the black American experience in Hernando County.

History is a collection of our life experiences. *Hernando County* assembles some experiences that have never been published before. The author has designed the project in seven themes. The first chapter presents some of the early personalities in the county's history's who lived in bondage and freedom. It also includes images of activities and relationships. The second chapter focuses on religious life. Churches, ministers, and church activities are highlighted in this chapter. Chapter three addresses education for blacks in the county. Portraits of schools, teachers, and graduates are included in this section. There are pictures of school activities also. Chapter four showcases portraits of our men and women who have served in the U.S. armed forces.

It is amazing that athletes from Hernando County have performed in some of the world's largest sports events, and so this is what chapter five focuses on. Chapter six explores careers and professions. Chapter seven captures the community-building spirit of individuals who played pivotal roles in the formation of secret societies, clubs, and social organizations and those who participate in funerals.

In conclusion, Black America Series: *Hernando County* is a testament that every community can tell its story. This project is just a beginning in many ways, but every project must start somewhere. It records a portion of our history as black Americans in Hernando County, and it leads to our bright future.

One

EARLY LIFE

Rev. K. E. Rodgers built the home on the right in the 1950s for Estella Blackson after her husband, Rev. W. C. Blackson, died. This act of kindness was a common practice during that era. The house on the left was built by Hampton St. Clair and Nathaniel O'Neal in 1889 on 160 acres in Twin Lakes, according to Mable Sims, Hampton's great-great-great-granddaughter. Hampton was a medicine man. His brother, Arthur W. St. Clair, was a county commissioner from 1875 to 1877.

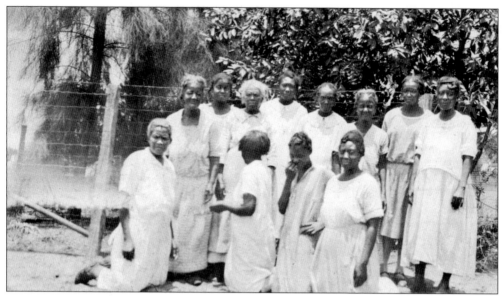

These are believed to be slaves at Chinsegut Hill. The one on the left resembles Aunt Lizzie Washington.

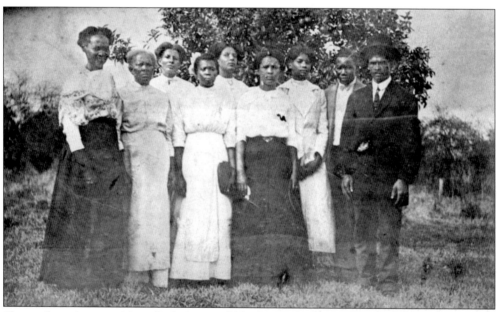

Shown here is an unidentified group of blacks, perhaps on Chinsegut Hill during the early 1900s.

Moody Timmons was born on July 4, 1857, and died June 4, 1947. He owned approximately 80 acres of land in Brooksville. Moody fathered 12 children with his first wife, Lester Waiters. He is pictured here with his second wife, Carrie Lang Timmons. A community just south of Publix supermarket in Brooksville is called Timmons Settlement. (Courtesy Carrie B. Martin.)

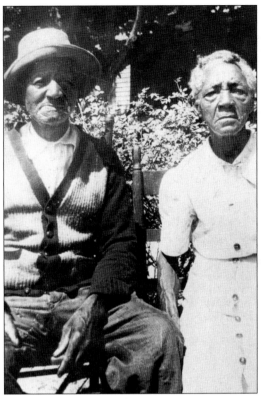

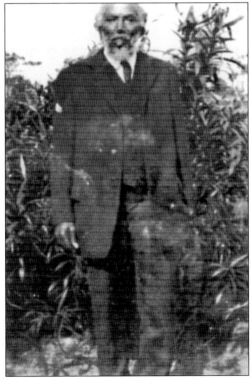

Nathaniel Brown Mayo came to Hernando County in the 1850s as a slave. He was raised in Russell Hill, which is now a part of Citrus County. Citrus County separated from Hernando County in 1887. Mayo was a farmer, and the family still owns land in Russell Hill. (Courtesy Brenda Mobley.)

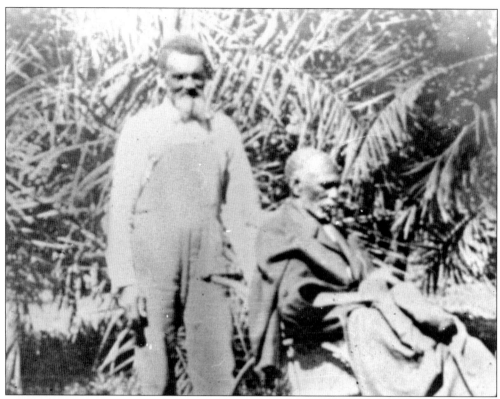

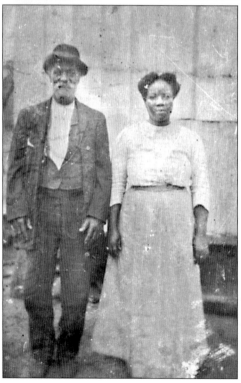

Former slave Gillum Washington owned 160 acres of land in a Citrus County community called Russell Hill. He died in 1931 at age 76. Gillum (left) and Phelan Harris are in the photograph. After a stroke confined Harris to a wheelchair, Gillum was hired by former slave owner Raymond Roberts to care for Harris. Citrus and Pasco Counties were part of Hernando County until the late 1870s. (Courtesy Beatrice Collins.)

Rev. Hampton St. Clair and Aunt Cindy were early settlers in the Twin Lakes community. Hampton was also a leader in the formation of the independent black church movement in Hernando County. This movement occurred around the mid-1860s. Blacks established their own churches independent of the supervision of whites. Aunt Cindy's last name is unknown; however, it is a common courtesy in the black community to express respect for elders with the title of uncle or aunt. Perhaps she was a family friend. (Courtesy Mable Sims.)

Lizzie Washington (also known as Aunt Lizzie) was 90 years old when this photograph was taken at Chinsegut Hill. Chinsegut means "the spirit of lost things." The owners of Chinsegut Estate owned slaves and retained them as help after the Emancipation Proclamation. Lizzie was remembered for her pipe and bare feet. She was a member of Shiloh Missionary Baptist Church. It was common Southern practice to also recognize loyal black helpers as uncle or aunt instead of Mr., Miss, or Mrs. (Courtesy Beatrice Collins.)

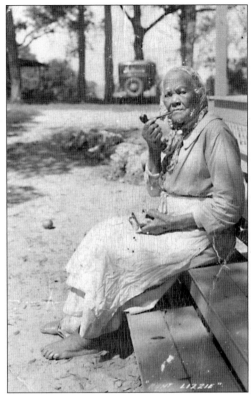

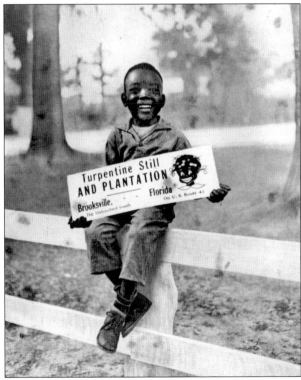

A young Willie D. Smith advertises the Lewis Plantation and Turpentine Still. Willie lived on the plantation. This is one of a number of advertisements that Pearce Lewis, owner of Lewis Plantation and Turpentine Still, used to promote the attraction, which featured mule-driven wagon rides and dancing by black adults and children (portrayed as Africans). The tourist attraction opened sometime after World War II and closed in the 1950s. It was a forerunner to other attractions such as Disney World. (Courtesy Margaret Reese.)

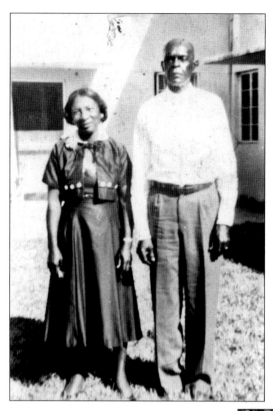

Willie "Will" and Queen Jones were pillars of the community in the 1930s, 1940s, and 1950s. Will was a deacon and Queen a deaconess at Bethlehem Baptist Church. Will was a community builder. He was active in the church and the Masons, and he reportedly tried to organize an NAACP branch in Hernando County prior to the modern civil rights movement. (Courtesy Arthur Virgil Thomas Jr.)

Levi Timmons, pictured here with his wife, Rosa, was the 9th of Moody Timmons's 12 children. Levi and Rosa had 11 children. The majority of Moody's children had large families, which was common during that era. (Courtesy Stephanie Richardson.)

The McGhee family was one of the early settlers of the Blue Sink community. Shown in this photograph are Pearl McGhee and her mother, Nancy Butler (seated). (Courtesy Thelma Mckeever.)

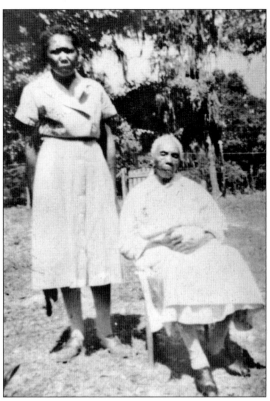

Walker Miller, shown here, is Freddie Douglas's maternal grandfather. Miller moved to Florida to live with his daughter Carrie and her family in Hernando County in the 1920s, but he left after constant harassment about his white features. The community thought he was white. (Courtesy Freddie Douglas.)

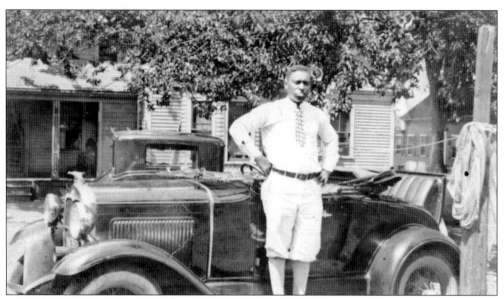

Ralph Byrd stands by a Model A sports car in his knickers and tie, probably in the 1930s. (Courtesy Mable Sims.)

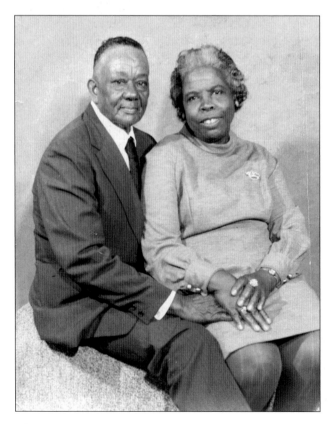

Clarence Langley Sr. and Ella Louise Langley celebrated their 50th wedding anniversary in 1990. Clarence was born in 1908 and died in 1990, and Ella Louise was born in 1912 and died in 2002. They raised 14 children in the Shady Rest community. Clarence worked at the Blue Sink School as custodian and bus driver, at Florida Rock Products Company, and at Chinsegut Hill. Ella was a housewife. Clarence was a deacon and trustee as Shiloh Missionary Baptist Church. (Courtesy Eloise Wright.)

Lavern Mayo Washington is the great-great-granddaughter of Nathaniel Mayo. She was active in the community and attended the first Dr. Martin Luther King Jr. Holiday Celebration at the courthouse in 1989. She was a domestic worker and the "mother" of the Shady Rest community. People came from all around to eat her good cooking.

Ethel Larry's family and friends enjoy a family picnic at an unidentified location in the early 1960s. Blacks had access to local lakes and ponds for recreational purposes prior to the population explosion of the late 1960s. Below, the group enjoys a swimming outing. Shown from left to right are (first row) Ethel Larry, Allie Thompson, and Hazel Land; (second row) unidentified, Margaret Brown, an unidentified child, and Cynthia Williams; (standing) Bruce Williams.

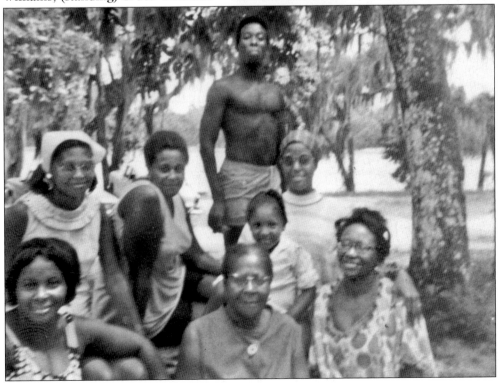

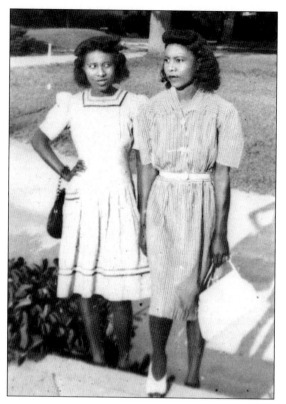

Teenage sisters Freddie Lee Douglas (left) and Connie Lee were photographed in Hernando County during their adolescence. Blacks were always taught to look their best at all times. This photograph is an example of girls prepared to attend a special event such as a wedding or church service. These girls came of age in the late 1930s or early 1940s. Freddie, a widow, lives in south Brooksville. Connie moved from Brooksville in the late 1960s to Daytona, where she died in 2005. Freddie is an artist, and during the 1960s, her home was decorated with the ranch-style paintings she did on cardboard boxes. She made the paint from clay. (Courtesy Freddie Douglas.)

The Willis family moved to Hernando County from Georgia in the 1930s. Sisters Annie Willis-Huggins (left) and Ruby Willis-Fletcher are photographed here. (Courtesy Beulah Lawson.)

William Wright moved to Hernando County from South Carolina in 1945. He had three children, Willie Mae, Annie Mae, and Louis. He worked at Emerson Block Plant and Camp Mining Company, and he helped build homes in the Hill N Dale community. He died in his early 80s in 1986. (Courtesy Annie Mae Goodson.)

Photographed in the early 1940s are Moody Timmons's youthful grandson, Henry Hart, and his wife, Margaree. Henry died in 1954, and Margaree lives in Timmons Settlement. (Courtesy Hazel Land.)

The Elijah Bennett family moved to Hernando County in 1946. This picture was taken in Kennedy Park in 1987. From left to right, shown here are Tara, Michael, Elijah John, Vera, Mary, Clarence (kneeling), Myers, Elijah, Edna (sitting), Dale (Imani), Freeman, Ronald, Sharon, Carmen, Mary Alice Rofile, Ronald, and Sarah.

The Waddy family is one of the largest, if not the largest, black families in Hernando County. From left to right are (seated) Fannie, Lula (the mother), and James; (standing) Bertha, Charles "Moody," Robert, Shirley, John, Alberta, Fred, Dexter, Myra, and Willie "Buddy." An older sibling, Collie "CD," passed away in the 1990s. The family moved to Brooksville in the 1940s from Alabama. (Courtesy Shirley and John Waddy.)

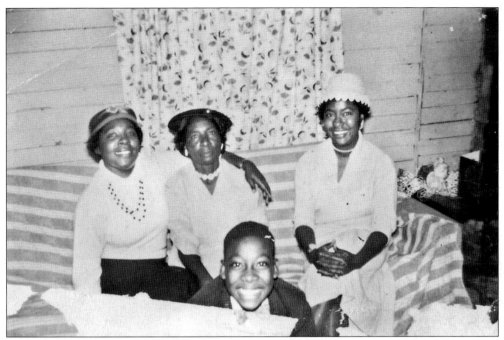

Will and Queen Jones' children were healthy and happy. They all graduated from high school. Photographed from left to right are Flora, Queen, Arletha, and (in front) Willie Jr. (Courtesy Arthur Thomas Jr.)

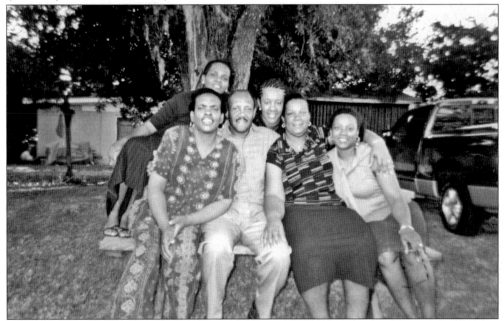

Ophelia Plair Nelson's children moved here in the 1960s. Seated from left to right are (first row) Angela, Carl, Fredricka, and Betty; (second row) Lisa and Ophelia. The picture was taken in 2004 in Brooksville the Friday before their sister Renee's funeral. Lisa, Carl, Ophelia, and Betty are all college graduates. Several of the siblings' children are pursuing college degrees. (Courtesy Ophelia Brown.)

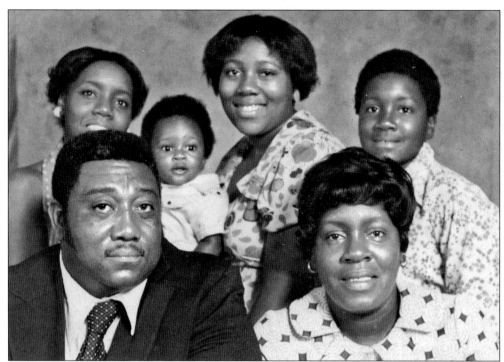

The Neal family, from left to right, is (first row) Lemon Sr. and his wife, Mae Pearl; (second row) Leveal, Lennis, Lillie, and Lemon Jr. Lemon Sr. was owner of L. Neal Grassing and Fencing, Inc. The company planted grass along the side of state and federal highways. (Courtesy Lillie Neal.)

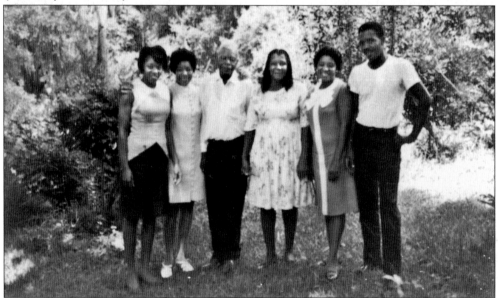

The Newton family lived in the Blue Sink settlement in Shady Rest. Shown from left to right are Lucille, Missouri, Andrew, Gracie, Bernice, and Thomas (T. C.). Not pictured are Alice, Beatrice, and Janet. The picture was taken in the late 1950s. (Courtesy Bernice Newton.)

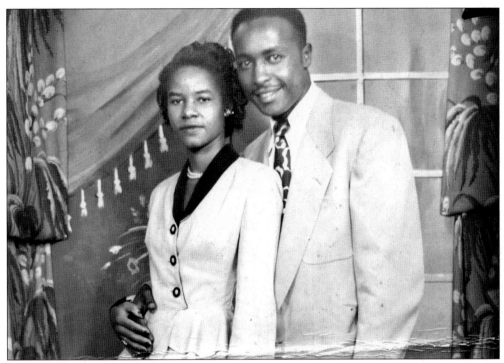

Clarence and Naomi Walker were active in the community most of their professional lives. They both are retired teachers. Clarence was a candidate for Hernando County Board of County Commissioners in the 1980s. (Courtesy Naomi Walker.)

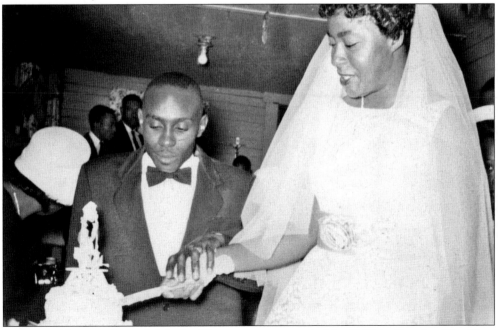

Arthur V. Thomas Sr. and Arletha Thomas were married in 1960 in Brooksville. They met at Bethune-Cookman College. Arthur was Moton High School's only band director. (Courtesy Arthur V. Thomas Jr.)

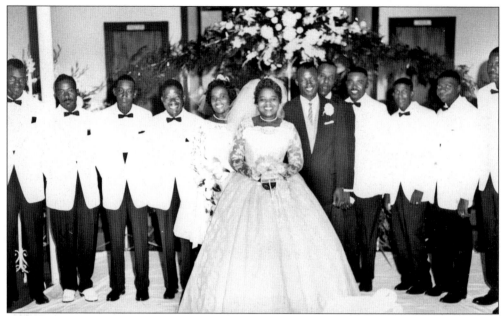

James and Barbie Hall's was one of the largest weddings in the black community. It was held on June 14, 1964, at Bethlehem Progressive Baptist Church. From left to right are Harold Morgan Jr., Eugene Redding, James V. Hall, Henist Washington, Ruby Hart, Barbie Hart Hall, James Hall, William "Roy" Wright Jr., James Washington Jr., David Thompson, Earl Wright Jr., and Harold Stephens (Courtesy Gina Hall.)

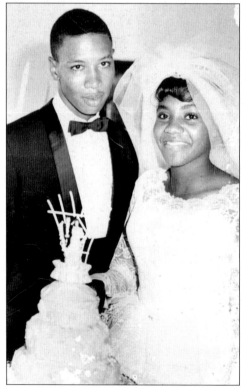

Jacqueline Wright and Evans Ward were married at Bethlehem Baptist Church in 1968. They met at Florida Agriculture and Mechanical College in Tallahassee, Florida. Jackie is a retired Fulton County teacher. (Courtesy Eloise Wright.)

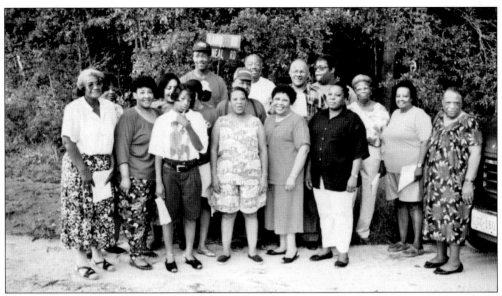

Approximately 300 people attended the 1992 Willis and Chester family reunion in Mondon Hill. Some of the local family members pictured here includes Annie Mae Lawson, Rev. Arnold Cunningham, Candace Harden, Sillar Townsend, Gladys Chester, Lillie Stephens, Martha Lawson, Liza Lawson, Edward Chester, Nathaniel Chester, Marshall Lawson, Abraham Chester, Gregory Chester, Hilda Willis, Sillar Lawson, and Annie Huggins. (Courtesy Evelyn Chester Henderson.)

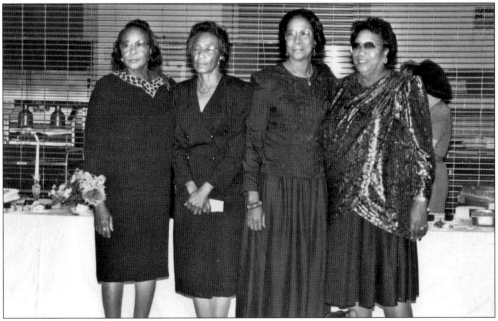

The Johnson sisters grew up in the Blue Sink and Shady Rest communities in the 1930s, 1940s, and 1950s. Freddie and Thelma still live in the community. Shown from left to right are Thelma (Johnson) Mckeever (teacher), Edna (Johnson) Willis (food service), Freddie Johnson (food service), and Pearlie Johnson (bus driver). The sisters retired from the Hernando County School District. (Courtesy Thelma Mckeever.)

Harry T. Hicks drove tractors right up to the time of his death. He worked in the Twin Lakes community where he lived off Dan Brown Road. He was in his 90s when he died. His wife, Lillian, and son, Bason, were killed in a tragic school bus accident in 1966. Harry worked as a custodian and bus driver for Moton High School for years.

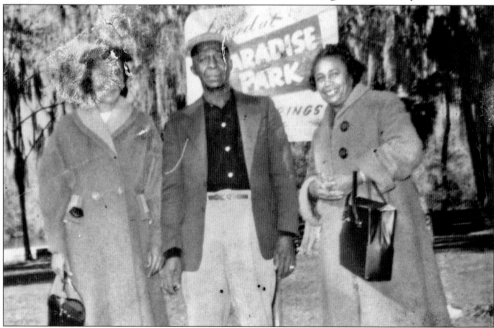

Viola (left) and Saul Larry's visit to Paradise Park, the Jim Crow version of Silver Springs in Ocala, Florida, is shown here. Blacks and whites were not allowed to swim together, so a separate park was built for blacks. Saul operated a bar, Saul's Place, in south Brooksville before he died in 1960. The woman with them is unidentified. (Courtesy Eloise Wright.)

Ms. Blanche Brewn was the cook for the Lewis Plantation and Turpentine Still. The Lewis Plantation and Turpentine Still operated in Hernando County in the 1940s and 1950s. The attraction featured blacks in stereotypical images. Blanche rings the bell to start the show for the wagon driven by Uncle Doug and a host of children. The show consisted of dancing and other forms of entertainment. (Courtesy Sarah Stewart.)

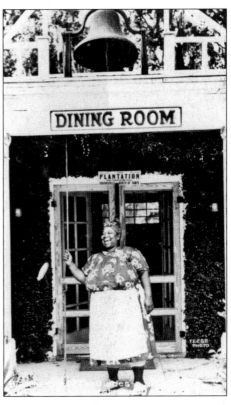

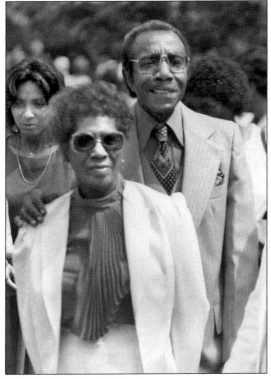

Earl Wright Sr. and his wife, Eloise, attended their granddaughter Donna's graduation from high school in Atlanta. They are parents of 10 children and were married for 57 years. Eloise is a retired teacher, having taught kindergarten for 24 years. (Courtesy Eloise Wright.)

Brothers John (left) and Willie Waddy fellowship after Arthur Drake's funeral. The brothers moved up the ranks in the mining industry. John is a part of the top management team and a plant manager. Willie is a retired plant manager for Florida Crushstone Corporation in Clermont. Both brothers served in the army, John in Vietnam and Willie in Germany.

Myers G. Bennett spent most of his working years harvesting fruits. He even followed the season, picking vegetables in Delaware and Maryland in the summertime and apples in upstate New York.

Two

RELIGIOUS COMMUNITY

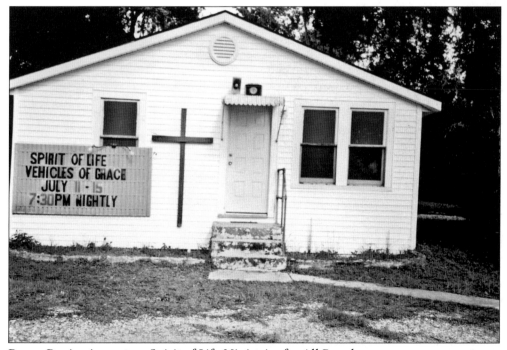

Byron Benjamin pastors Spirit of Life Ministries for All People.

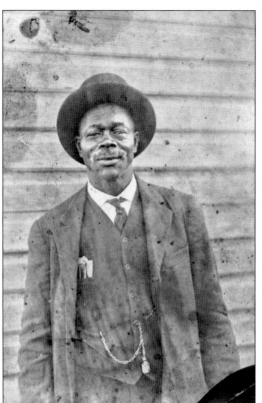

Circuit preacher R. L. Stevens was the third pastor of Mount Pleasant Missionary Baptist Church in Twin Lakes during the late 1800s. Circuit preachers were common in that day. Most churches held services twice a month—either the first and third Sundays or second and fourth Sundays.(Courtesy Mable Sims.)

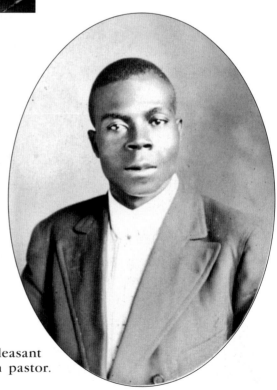

Rev. W. G. Blackson was Mount Pleasant Missionary Baptist Church's ninth pastor. (Courtesy Mable Sims.)

Rev. Ira Bryant was a former pastor of
St. James Missionary Baptist Church.
He is photographed with his wife,
Anna, during their golden years.
(Courtesy Anita Scrivens.)

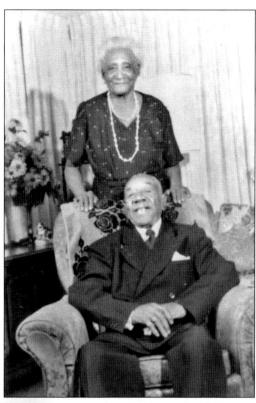

Rev. Willie A. Brooks was a
former pastor of St. James
Missionary Baptist Church.
(Courtesy Willie James Brooks.)

31

Rev. Genevieve Spears is the pastor of the Damascus Mission Faith Outreach, Inc., in Ridge Manor, Florida. Genevieve has been a minister for 25 years. She is a licensed practical nurse.

Blacks had an early presence in the Twin Lakes community. Here are three prominent women from the Twin Lakes community in the late 19th or early 20th centuries. They are, from left to right, Estella O'Neal Blackson, the wife of Rev. W. G. Blackson; Precious St. Clair O'Neal, the daughter of Rev. Hampton St. Clair; and Lennie Pierce. (Courtesy Mable Sims.)

Ella Stephens was one of the early converts of the holiness movement. She was a church mother and minister at the Church of the Living God. One of her common expressions was "Living Holy." The holiness movement emerged in the 1920s. The holiness church is identified by the use of drums and guitars and speaking in tongues. The term "Pentecostal" has replaced holiness. They were considered backward and primitive by some other denominations. (Courtesy Ell Mae McAuley.)

Elder James Perkins was pastor of the Church of the Living God on Twigg Street. He was one of the leaders in the holiness movement in Brooksville. A new church structure was built in the early 1970s. It is located just opposite Holy Band Deliverance Church on School Street. Elder Juanita Johnson is the senior female pastor in the community. (Courtesy Brittany Scriven.)

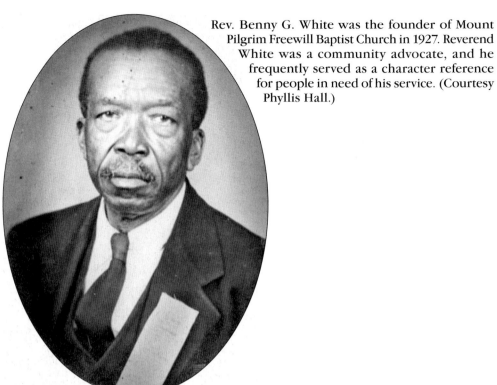

Rev. Benny G. White was the founder of Mount Pilgrim Freewill Baptist Church in 1927. Reverend White was a community advocate, and he frequently served as a character reference for people in need of his service. (Courtesy Phyllis Hall.)

Mount Pilgrim Freewill Baptist is located on School Street next to old Moton High School. It is a member of the United Freewill of American Association. Rev. B. G. White was its founder. Rev. Kenneth Brown is its current pastor.

Elder Leonard Hansberry was pastor
of New Jerusalem on Armstrong
Street. Elder Hansberry was a protégé
of "Father Roberts," a traveling
minister who toured the area during
the height of the citrus season. New
Jerusalem in Dade City and New
Jerusalem in Brooksville emerged
from Father Roberts's ministry.
(Courtesy Pearline Drake.)

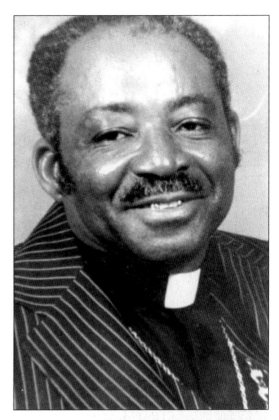

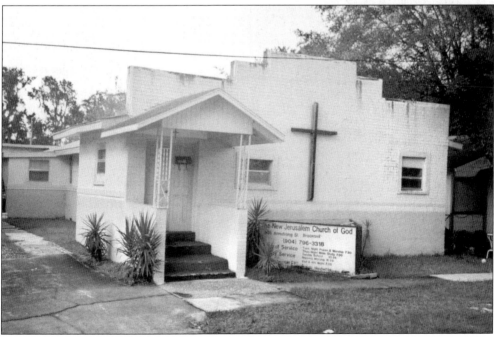

New Jerusalem Church of God was built in the 1950s, and Beatrice Carr is the current
pastor. She is one of the few female pastors in the community today.

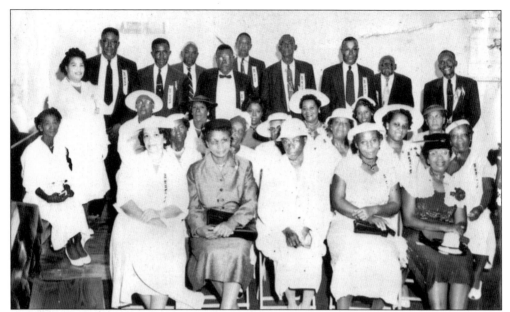

Bethlehem Progressive Baptist Church's deaconesses, deacons, and trustees posed for a photograph at the church in the 1960s. Some of the church leaders included here are Rosa Fletcher (seated on the wall), Carie Duckett, Gertude McGhee, Charity Mobley, Nelia Mills, Ruby Hart, Annie Lee Henry, Cora Timmons, Janie Wright, and Isabella Black. The deacons and trustees are Willie Calhoun, Plass Hammon, Jessie Tucker, Elijah Cole, James Henry, Willie Jones, Moody Hart, and McMahon Williams. (Courtesy Carrie B. Martin.)

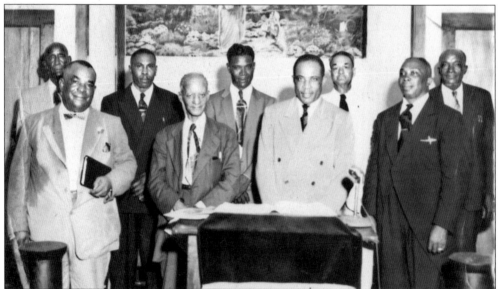

Ministers are in rank at Bethlehem Progressive Baptist Church's pulpit. Some of the ministers identified in the picture are Washington Mobley (left, second row), C. H. Bolden (center, second row), Shepard Mills (right, second row) and Lewis McGhee (right, first row). McGhee replaced C. H. Bolden in 1960 as pastor of Bethlehem. McGhee died in 1992. (Courtesy Carrie Martin.)

Emeritus State Elder Willie Brown Sr. died on May 29, 2005. He was 98 years old and had been good health until the last months of his life. He was the founder of the Josephine Street Church of the Living God.

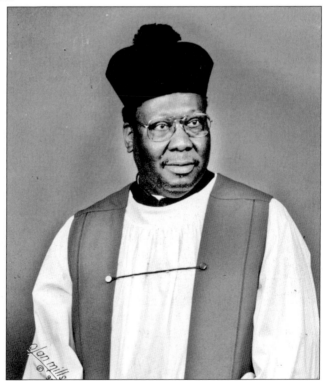

Bishop Theodore N. Brown of Church of the Living God, Inc., is shown here. He supervises approximately two dozen churches in Florida and Georgia. His wife, Gladys, pastors one of his churches in Hernando of Citrus County. His home church is Josephine Church of the Living God in Brooksville, Florida. A large number of his followers have accepted calls to the ministries under his leadership. Bishop Brown is active in the Minister Lay Alliance of Hernando County. He is a retired mathematics teacher. He also played semi-pro baseball for the Brooksville Giants. (Courtesy Bishop Theodore N. Brown.)

Shown here are Ebenezer Missionary Baptist Church ushers Mae Alice Ingram (left) and Sarah Stewart. This photograph was taken in the 1950s. (Courtesy Mae Alice Ingram.)

Shown here from left to right are Maul Brown; Rev. Lewis E. McGhee; McGhee's wife, Gertrude; and Nelia Mills attending a convention in Texas. This photo was taken in the 1960s. (Courtesy Eloise Wright.)

Rev. Lewis E. McGhee organized and was the first pastor at First Baptist Missionary Baptist Church in Shady Rest in 1942. McGhee was pastor of Bethlehem Progressive Baptist Church from 1960 to 1992. He lived well into his 90s and died as pastor in 1992. He organized the Junior Choir Federation and was active in the First South Florida Association. As pastor of Bethlehem, McGhee always drove a Cadillac and dressed formally in all public settings.

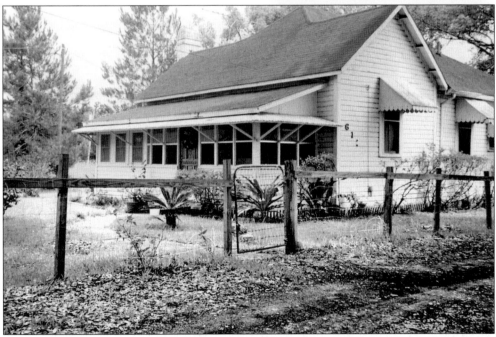

This is the home of Rev. Lewis McGhee and his wife, Gertude, located on the corner of South Brooksville Avenue and Smith Street near Bethlehem Missionary Baptist Church. Lois Hinton is the present owner of the house.

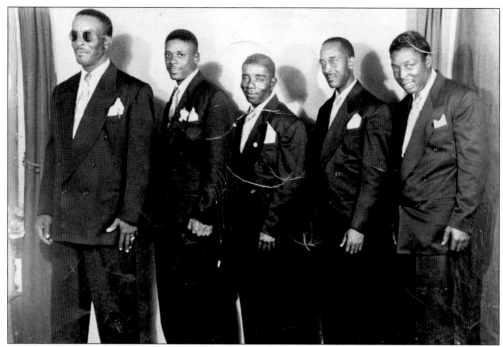

Male quartets were popular components of the religious communities until the mid-1960s, and Brooksville was no exception. Standing from left to right are Robert Montgomery, L. H. Goodson, Leroy Washington, James Jones, and Willie Bryant. (Courtesy Mae Alice Ingram.)

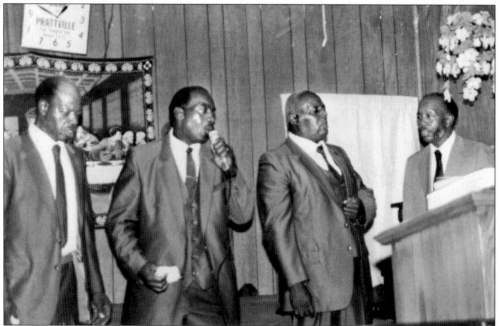

The Hernando County Male Chorus is a modern-day version of the old gospel quartets. This group is singing at a church in Alabama. Pictured from left to right are J. P. Willis, Archie Bell, Leo Goodson, and Marshall "Tippy" Lawson. (Courtesy Annie Mae Goodson.)

Bethlehem Missionary Baptist Church, when it was located in Rabb, is in the background. The members in the photograph are unidentified. (Courtesy Arthur V. Thomas Jr.)

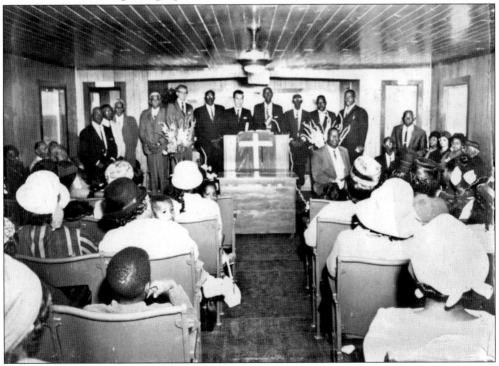

Local ministers attend Rev. David C. Stewart's installation as pastor at St. James Missionary Baptist Church in Wiscon around 1960. Reverend Stewart is standing in the pulpit on the far right. (Courtesy David C. Stewart Jr.)

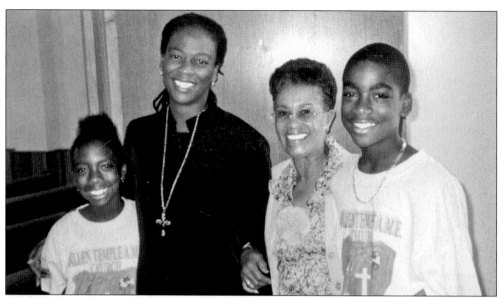

Rev. Joy L. Gallmon (second from left) is the pastor of Allen Temple African Methodist Episcopal Church in Brooksville. Joy is a graduate of Tuskegee University in Alabama and graduated from seminary at Emory University in Atlanta, Georgia. Members of her family are photographed with her.

Allen Temple African Methodist Episcopal Church, organized in June 1870, was located in downtown Brooksville in the Cat Slew community until the late 1940s, when it moved to the current Leonard Street location, pictured here. The city of Brooksville passed a zoning law in the 1940s that resulted in blacks moving out of the downtown part of the city. From left to right are (kneeling) two unidentified; (first row) Johnny Williams, Sarah William Hasty, Annie R. Quarterman, Arline Anderson, Willie Anderson, Willie Black, and Reverend Newton; (second row) Rosetta Thompson, Mark Thompson, Inez Bryant, Caroline ?, unidentified, Johnny Huggins, unidentified, and Cora Hasty; (third row) Nathaniel Chester, Eva Brown, Blanche Cambric, Georgia Lawrence, Sarah Stewart, Lillie Gilyard, Johnnie Mae Redfield, Eddie Willis, and Walter Willis. (Courtesy Sarah Stewart.)

The Mount Pilgrim Freewill Baptist Church Choir is show here. From left to right are (first row) Herman Johnson, Sylvia Clark, Jennie White, Phyllis Hall, Annie Mae Walker, Nancy White, and Lula Mae White; (second row) Mildred McGhee, Victoria Lynch, Harold Stephens, Annie Clark, Clyde Clark, and James Robert Clark. (Courtesy Bennie Clarke.)

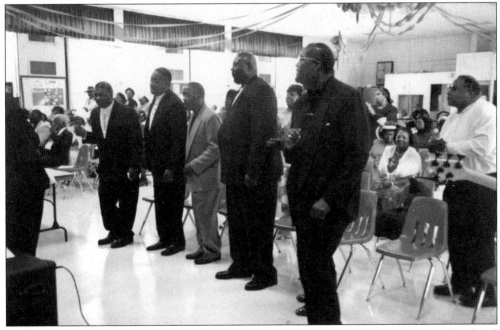

Members of the Hernando County Male Chorus perform at the 2002 Moton High School Reunion in the school's cafeteria. From left to right are Walter Moore, Lemon Neal Jr., Ernest Roberts, Larry Everett, and Samuel Cook. Grant Gibbs and David Cook are not pictured because they were adjusting the equipment.

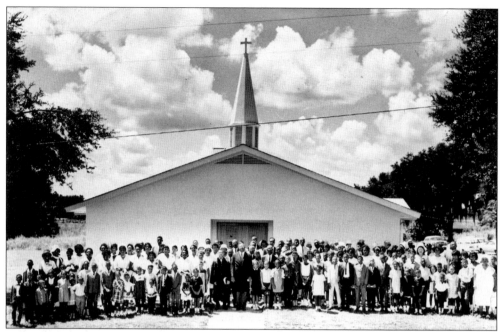

In the 1960s, Ebenezer Baptist Church relocated from the community of Rabb to Wood Drive. Dr. Burdell Strickland is the current pastor. (Courtesy Mae Alice Ingram.)

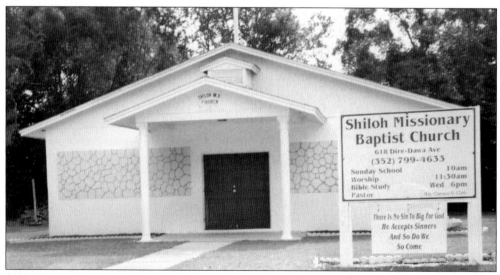

Shiloh Missionary Baptist Church moved to its Brooksville location in a wood structure in the 1960s from Russell Hill in Citrus County. Russell Hill Cemetery was located adjacent to the old church. Slaves in the community attended Eden Baptist Church in the Lake Lindsey community and later Hebron in Lecanto.

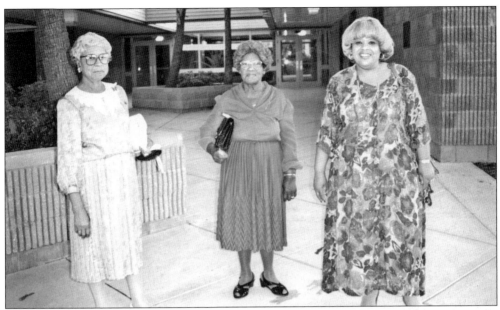

Three members of Bethlehem Progressive Baptist Church attend a retirement party at the new Moton Elementary School. From left to right are Ruby Hart, Vera Byrant, and Barbie Hall. Ruby and Vera were dedicated workers at the church. Ruby also worked for the town father, Alfred McKethan, who spoke at her funeral. Vera Byrant was one the charter members of the Grand Assembly of the Lilly Whites, Lodge #7 in 1937. She sold the *Pittsburgh Courier* newspaper. Vera retired from Lykes Memorial Hospital and volunteered after retirement. Barbie Hall taught school in Hernando County for more than 30 years and was president of the Black Educators Caucus of Hernando County. Barbie was also the Moton High School class of 1957 salutatorian. (Courtesy Evelyn Chester Henderson.)

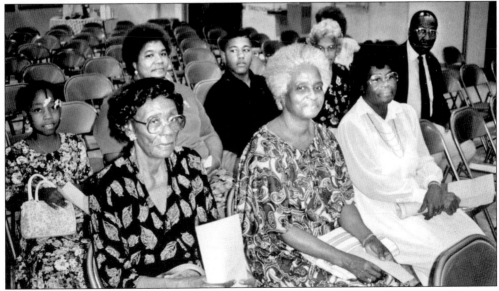

Members of Mount Zion African Methodist Episcopal Church listen during a retirement celebration in 1993. From left to right on the first row are Elizabeth Black, Beulah Willis, and Hilda Willis.

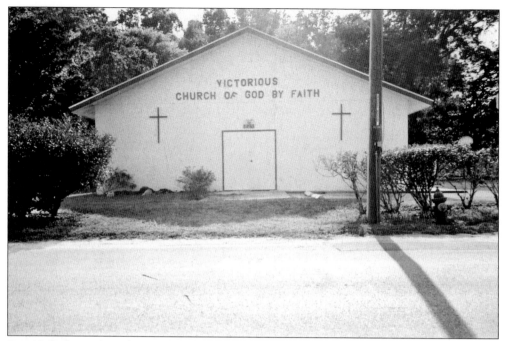

Rev. Malachi Fogle is the current pastor of Victorious Church of God By Faith. The church organized in a storefront building in the 1980s. The current property was purchased from Southside Church of Christ when it closed in the mid-1990s.

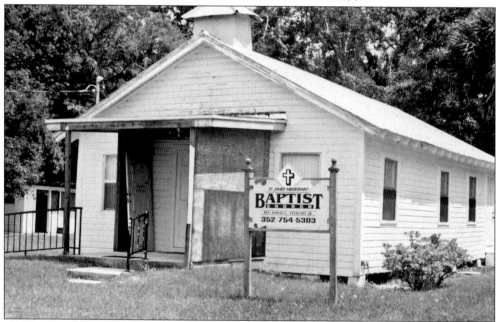

St. James Missionary Baptist Church is located on Wiscon Road and has been in existence for more than 100 years. The current church is similar to many of the early churches in architectural design. David C. Stewart Jr. is the current pastor. The church membership has consisted of families in the neighborhood such as the Scrivens, Blounts, Ingrams, Mobleys, and Waiters.

First Baptist Church in Shady Rest was organized in 1942 by Rev. Lewis E. McGhee. It is the last Baptist church to be built by blacks in Hernando County.

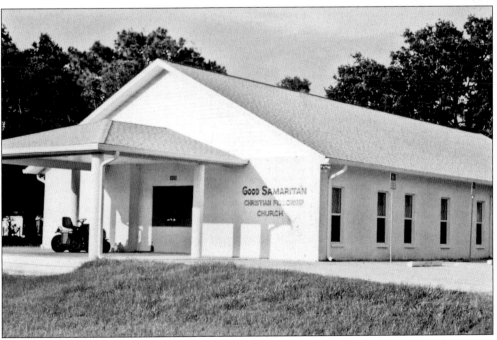

Good Samaritan Christian Fellowship Church is located in Mondon Hill, and it is one of the newer churches in the community. Douglas Maura is the pastor.

Prophetess Stella Williams, pastor of Holy Band Deliverance Temple, Inc., is one of a growing number of females who have answered the calling into the ministries. She is one of a handful of female pastors in the black community. The Holiness/Pentecostal and African Methodist Episcopal churches are friendlier to the idea of female ministers than the Baptist churches.

Holy Band Deliverance Temple, Inc., was founded in the late 1960s in old Ebenezer Baptist Church in Rabb. Holy Band Deliverance Temple worshipped in two storefronts before landing here on Twigg Street in 1976.

Allen Temple African Methodist Episcopal Church is currently located on Leonard Street. It is one of two AME churches in the community.

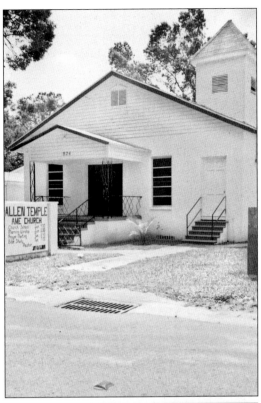

St. Lewis Missionary Baptist Church in Blue Sink is now known as Shady Rest off of U.S. Highway 41 North in Brooksville. This church is more than 100 years old. Even though this is one of the oldest churches in the community, it is the least-known church.

Mount Pleasant Missionary Baptist Church is 134 years old, and Bishop James Dixon is pastor. The church is located in Twin Lakes off of Church Road.

Josephine Street Church of the Living God is co-pastored by Jimmy Brooks and Ralph Vanlow. It has clearly been the most popular church in the community during the past 20 years.

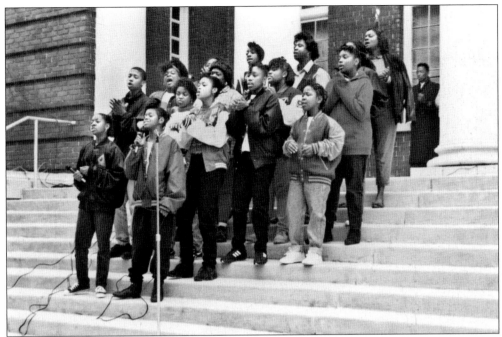

Josephine Street Church of the Living God Youth Choir performs at a Dr. Martin Luther King Jr. Holiday Celebration on the Hernando County Courthouse steps in downtown Brooksville in early 1989. Youth were always requested to participate on the program for the event. (Courtesy Henry Wright.)

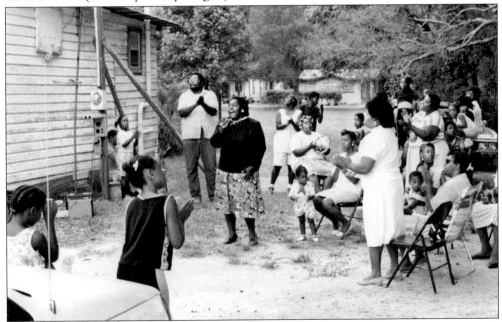

Elder Irene Wells (standing center) leads a weekday prayer service next to Rev. David Stewart's barbershop on Summit Road in the early 1990s. Elder Wells is the pastor of two churches, New Jerusalem at Twin Lakes and New Jerusalem in Chiefland, Florida. She is a popular singer and is highly requested to sing at special events.

Rev. David Swackard Sr. and his wife, Arletha, are active in the religious life of the community. He is the former pastor of Mount Moriah Baptist Church in Lacoochee and First Baptist Church in Shady Rest. He is currently pastoring a church in Clearwater.

Rev. Nathaniel Sims was called to pastor St. Paul Missionary Baptist Church in Dade City in 2004. He is a 1964 graduate of Moton High School. After living in New York for years, he returned home in the 1990s and has been working tirelessly to improve the quality of life for residents of the county. He is also chair of the NAACP organizing committee. Reverend Sims is pictured here with his wife, Ardell. (Courtesy Henry Wright.)

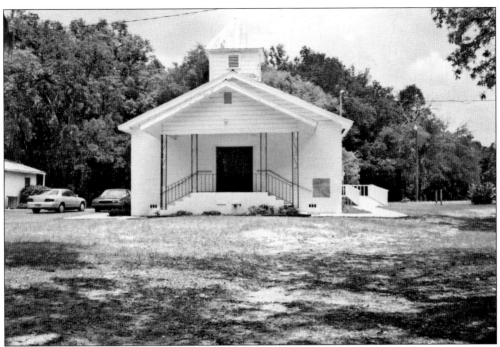

Mount Zion AME Church is more than 100 years old and is located in Mondon Hill off of WPA Road, just east of Brooksville.

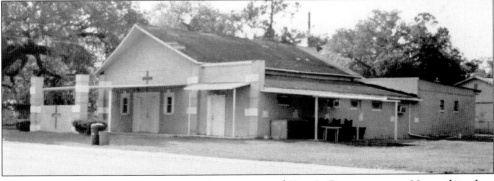

Deliverance Temple Ministries, Inc., is a renovated Varn's Grocery store. Many churches began this way. The church is one of the younger churches in the community and organized in the 1980s. Elder Freddie Lee Hudson is pastor.

Rev. Sharon Griffin Vickers, Ph.D., returned to the community after a career in the military. Sharon was one the student leaders who initiated the Hernando High School Black Student Walkout in 1969. She is currently working in Baghdad, Iraq, for Halliburton Corporation. (Courtesy Kimberly Harris.)

Members of the Stewart family pose for a photograph in Allen Temple AME Church in Brooksville. The roses suggest that it was a special day like Men and Women Day or a church anniversary. From left to right are Bernice Johnson, Frances Stewart, Henry Stewart, and Vera Chester. (Courtesy Sarah Stewart.)

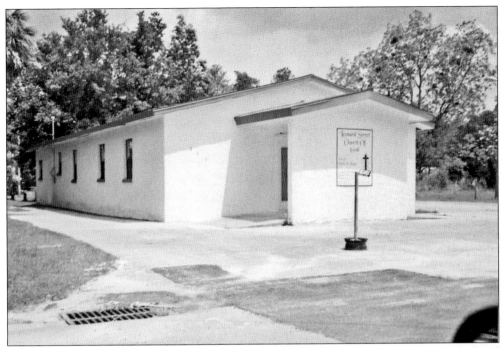

Leonard Street Church of God—located on Leonard Street—sits immediately behind Holy Band and on the same street with Allen Temple AME. It is a Holiness church. Pastor Elder T. Fagan is the current pastor of the Leonard Street Church of God.

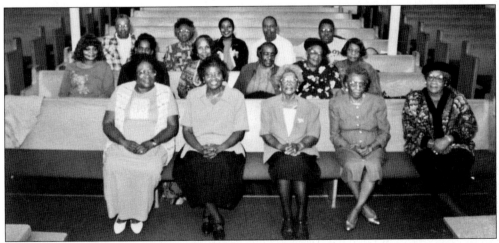

Members of Bethlehem Progressive Missionary Baptist Church Bible Study pose for a photograph for their anniversary booklet. Rev. C. A. Hubbert is the current pastor. Shown from left to right are (first row) Hazel Land, Carrie Martin, Vera Bryant, Eloise Wright, and Irene Scrivens; (second row) Peggy Henry, Isabel Harris, Alyce Walker, unidentified, Eva Baylor, and Mildred Sims; (third row) Willie Brooks, Sarah Davis, Ardell Sims, Nathaniel Sims, and James Bobby Holland. (Courtesy Eloise Wright.)

Chad Jones is a 2002 *St. Petersburg Times* Scholar. The honor is awarded to a high school senior who overcame personal obstacles to earn his or her diploma and comes with a $60,000 scholarship. Chad is a senior at Washington University in St. Louis, Missouri, majoring in architecture.

Below left: Everett Robinson III was the student speaker for Hernando High School's first Black History Week Assembly in February 1971, a celebration of blacks' contributions to world civilization. It entailed lectures and a little singing. In 1976, Pres. Gerald Ford changed Negro History Week to Black History Month. Carter G. Woodson began the celebration in 1926.

Below right: Courtney Rumala, a University of Iowa George Washington Carver Scholar (pre-collegiate research program), recently earned her associate in arts degree from Pasco-Hernando Community College and is an agriculture major at the University of Georgia in Athens. Courtney is also the state vice president for the National Achievers Society.

Three

EDUCATION

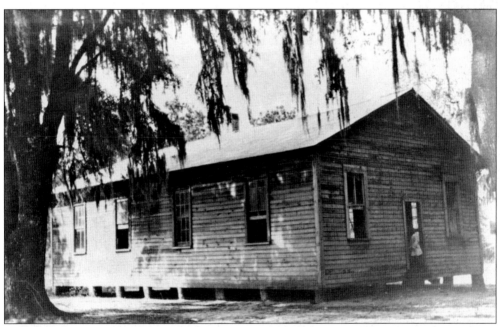

The one-room schoolhouse concept was common in many parts of the country during the first half of the 20th century. There were several one-room schools for blacks in Hernando County, such as Mondon Hill, Blue Sink, and Bay Spring. Schools were located in most of the black settlements. The Mobley School, shown in this photograph, was located in the Mobley settlement. The early school year was approximately three months. Public education for blacks began in the 1870s in Hernando County. (Courtesy Heritage Museum.)

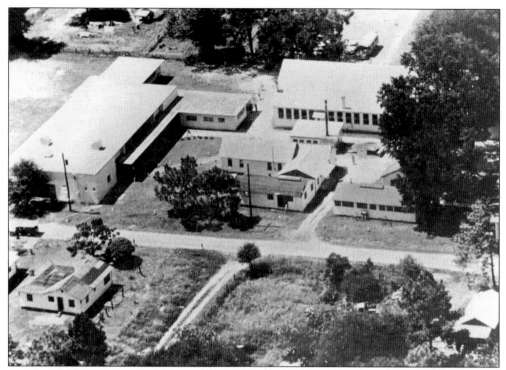

Moton School was the combination of an elementary and high school on one site. The one-room schools from several communities were consolidated into a single school during the early 1950s. (Courtesy Heritage Museum.)

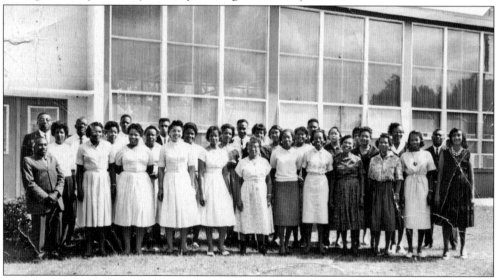

The Moton School faculty in the early 1960s is shown here. Included are John D. Floyd Sr., J. E. Adams, Margaret Brown, Bennie Clarke, Odecee Chestnut, Sarah Davis, Irene Edward, Ira Floyd, A. R. Franklin, L. C. Gross, Hattie Harris, Barbie Hart, Katie Inmon, Annie Lawson, Mary Love, L. C. Parker, Theresa Raines, E. Smith, Carol Stewart, Ida L. Stubbs, Rosa Taylor, A. V. Thomas, Clarence Walker, Naomi Walker, Wilma P. William, and Jennie L. Wright. (Courtesy Heritage Museum.)

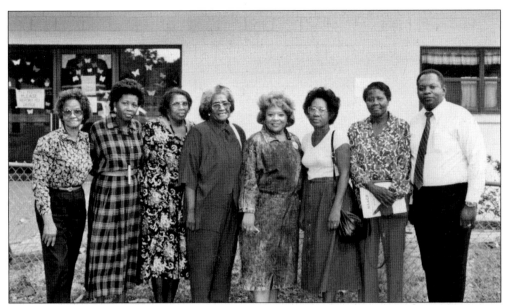

The Black Educators Caucus of Hernando County is an advocacy group that formed in the 1980s to empower black teachers in the county. Some members of the organization, pictured here from left to right, are Naomi Walker, Christene Yant, Betty Morgan, Annie Mae Lawson, Barbie Hall, Sarah Davis, Carrie Martin, and Lorenzo Hamilton. The organization issues a $1,000 scholarship to a deserving high school graduate. (Photograph by Imani D. Asukile.)

Carol Stewart, Black Educators Caucus of Hernando County Educator of the 20th Century, is the organization's founder and the 1990 Moton High School 50th Reunion Steering Committee co-chairman. (Courtesy Henry Wright.)

Dr. Robert W. Judson was president of Pasco-Hernando Community College from 1994 to 2005. When he retired in February of that year, he was one of the last of PHCC's original employees who started when the college opened in 1972. The college's endowment doubled, and employees' benefits were expanded during his tenure. (Courtesy Pasco-Hernando Community College.)

Irvin Homer is one of the county's best known volunteers. He was named Alfred McKethan Citizen of the Year by the Greater Hernando County Chamber of Commerce in May 2002. He is a member of the Pasco-Hernando Community College District Board of Trustees and serves on a number of advisory committees in the community. (Courtesy Pasco-Hernando Community College.)

Rev. Wilbur Bush and classmate Dorothy McGill share a laugh at a Moton High School reunion. They were members of the class of 1954.

The late Ida Stubbs, longtime sixth-grade social studies teacher, taught moral and character education. She was a big fan of the Los Angeles Dodgers because they broke the baseball color line by signing Jackie Roosevelt Robinson in 1947. Her classroom was one of the only ones to be equipped with a television. Her classes always got to watch the World Series when the games were played in the daytime.

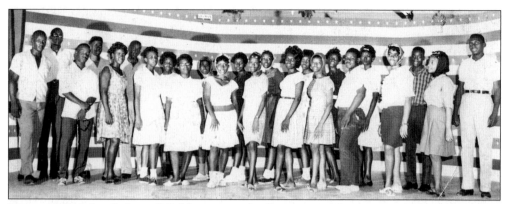

Moton High School class of 1966 prepares for the Junior-Senior Prom in this image. The prom was one of the biggest social events in the community. It was a rite of passage into adulthood for the students and an opportunity for social engagement for selected adults. These students were likely in their junior year, since juniors were responsible for decorating. (Courtesy Naomi Walker.)

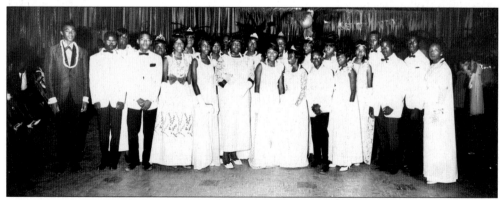

Moton High School's last graduating class, the class of 1968, posed for a prom picture in the school's cafeteria. (Courtesy Bennie Clarke.)

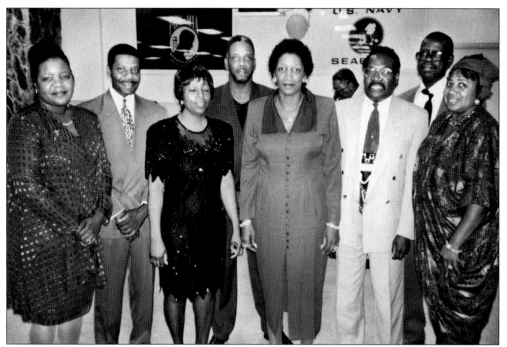

Members of Moton High School class of 1967 included, from left to right, Julie Blount, Saul Wright, Gwendolyn Lawson, Sam Willis, Hattie Washington, Mack Washington, Ronald Bennett, and Jo Anne Washington-Harres.

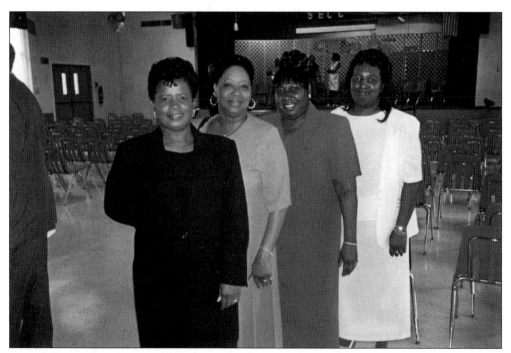

From left to right, classmates Barbara Fletcher, Joan Kincade Moore, Sarah Huggins, and Annie Mae Johnson reconnect at a 2002 school reunion for the class of 1966.

Above left: Secretary Johnnie Redfield attended Florida Agricultural and Mechanical University. She is one of the few members of the 1967–1968 Moton High staff who is still employed in the school system. The school graduated its last class in June 1968.

Above right: Angela Yvonne Smith-Turner is a child welfare program supervisor for the state of Alabama in Birmingham. She attended Tuskegee University and the University of Alabama. She graduated from Hernando High School in 1970.

At left: Gerald Redfield, Moton High School class of 1968, receives his master's degree from the University of Redlands in this 1982 photograph. He earned a bachelor's degree from Florida Agriculture and Mechanical University.

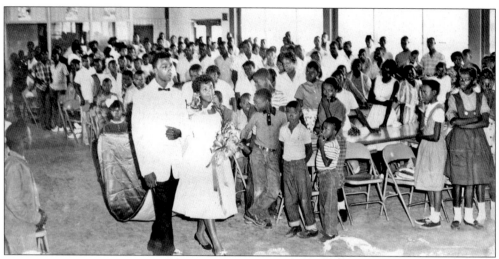

Jacqueline Wright, Miss Moton High School 1962–1963, is escorted by Lewis Brown during a Moton school assembly in the cafeteria. (Courtesy Eloise Wright.)

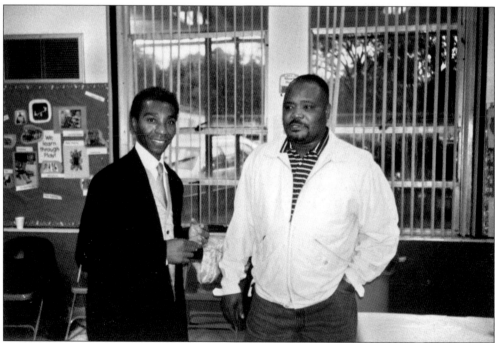

Hernando High School class of 1974 classmates Ronnie Wright and Howard Blount, M.D., catch up on past times at Ronnie's father's funeral repast in the old Moton High School cafeteria. Ronnie unsuccessfully ran for a school board seat in the late 1970s. Howard was president of the Kennedy Youth Club their senior year in school.

Members of Moton High School class of 1968 also participated in the Great Society program Upward Bound. Great Society, also called the War on Poverty, is the name of Pres. Lyndon B. Johnson's civil rights legislation, whose aim was to assist in the elimination of poverty. Some examples were Upward Bound and Headstart. Pictured here from left to right are (kneeling) unidentified; (standing) Jane Wright, unidentified, Donna Kincade, and Eddie Bryant Jr. Several members of this class attended Florida Memorial College in Miami as a result of participating in Upward Bound. The program is designed to enhance first-generation college students' readiness for college by providing an academic push while the students are still in high school. (Courtesy Sillar Lawson.)

Above left: Mary Jane Chester was a member of the first wave of African American students to integrate Hernando High School in 1965. She graduated from Hernando High School in 1967.

Above right: Frank Wilson opted to attend Hernando High School instead of the more traditional Moton High School. He graduated in 1968. Frank attended Morris Brown College, pledged Kappa Alpha Psi, and currently works for Martin Marietta. (Courtesy Sillar Lawson.)

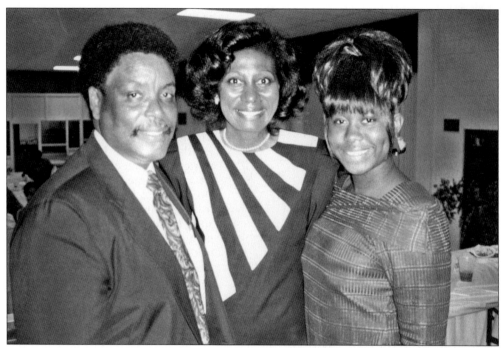

Former circuit court judge Ralph Pearson and his wife, Cheryl (center), congratulate the Black Educators Caucus 1994 Marie Antoinette Lawson Scholarship recipient, Wendy Oliver. Judge Pearson from Miami, Florida, was the banquet speaker. Ralph is a 1962 Moton graduate. Wendy earned her bachelor's and master's degrees from Florida Agriculture and Mechanical University.

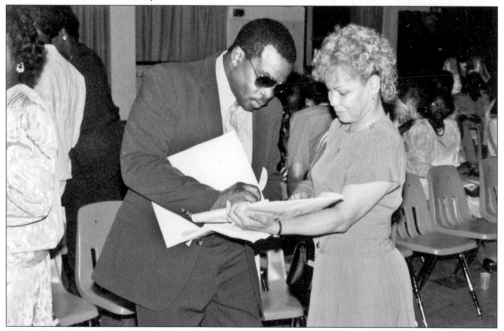

Willie Stephens and Mary Frances Hover exchange notes at a Moton reunion in 1990. Willie was a teacher, principal, and administrator for the Hernando County School District.

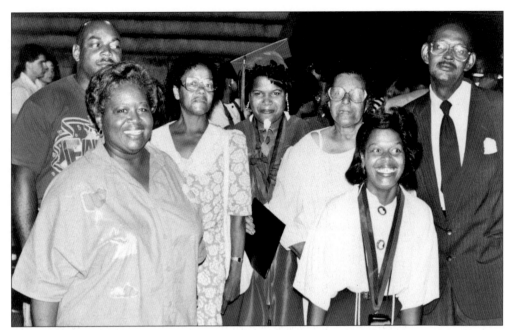

Alisha Barnes's family celebrates her graduation from Pasco High School in Dade City in the early 1990s. Photographed from left to right are (first row) Ella Mae McAuley and Violet Barnes (with medallion); (second row) Lionel "Butch" Oliver, Mary Roberts, Alisha Barnes, Cornelia Barnes, and Willie "Bobby" Roberts.

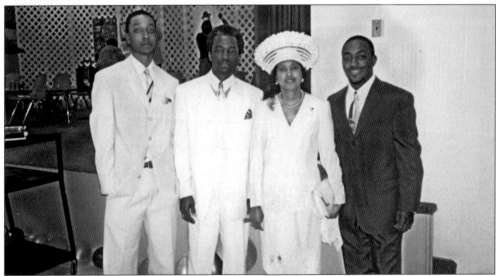

The Scrivens family believes in the value of education. Shown in the photograph are Herman, Bishop Herman, Anita, and Bryant. Herman is a licensed stockbroker; Bryant is an attorney; and Anita is a retired banker. Bishop Herman Scrivens teaches at the family's alma mater, Hernando High, after working for Florida Power for years. Daughter Brittany is missing from the photo. All three of Reverend and Anita's children earned associate in arts degrees from Pasco-Hernando Community College at the same time they earned their high school diplomas through the dual enrollment program. Bishop Herman was the Sunday morning preacher for the 2002 Moton Reunion.

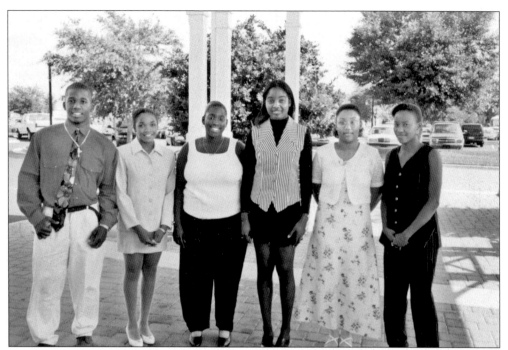

Shown from left to right are the 1998 African American Club of Hernando County, Inc., Scholarship recipients. They are Keylow King, Tracy Austin, Alaina Alexander, Trecia Swanston, Huldah Comrie, and Sandy Bullock. The banquet was held at Silverthorne Golf and Country Club.

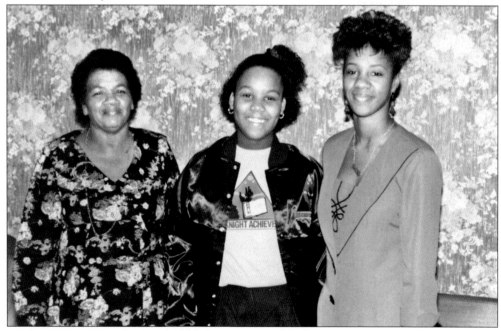

Lakisha Plair's grandmother, Ophelia Nelson (left), and aunt, Ophelia Frazier (right), congratulate Lakisha for her induction into the McKnight Achievers Society. The event was held at Beulah Institutional Baptist Church in Tampa.

Wanda Williams and her aunt Alfreeda Harrington bond at the conclusion of Wanda's graduation from Hernando High School in the 1989.

Mother, Christine Hudson, and daughter, Marguerita "Sissy" Taylor, enjoy a warm moment after a 1989 Hernando High School graduation.

Blanche Cambric Academy, Inc., students are prepared to attend 4-H camp at Camp Ocala. The after-school tutorial program was housed in the Brooksville Housing Authority community room. Pictured from left to right are (first row) Erica Kincade, Yolanda Frazier, Eshonda James, Eric Kincade, Yolanda Williams, unidentified, and Keshia Burnett; (second row) Elsie Burnett, Jerica Greene, Quincy Hammond, Maleshia Edwards, Joy Griffin, Rhonda Williams, and Ronald Williams.

The Pasco-Hernando Community College Center of Excellence History and Cultural Brain Bowl Team competed at the state competition at the University of South Florida Embassy Suites Hotel. From left to right are (first row) Linda Brown (coach), Theresa Brown, Morrisa Kendrick, Livia Sutedja, and Courtney Rumala; (second row) Imani Asukile (director), Takiyah Robinson, Chad Jones, Kay Blagrove (coach), and Joyce Jones (coach).

Zainabu Rumala earned her associate in arts degree from Pasco-Hernando Community College at age 16 and a bachelor and master of business administration degrees from the University of Florida. She was the state president for the prestigious honors program for minority students, McKnight Achievers Society (National Achievers Society). In 2006, she is a candidate for the jurist doctorate degree from the University of Florida.

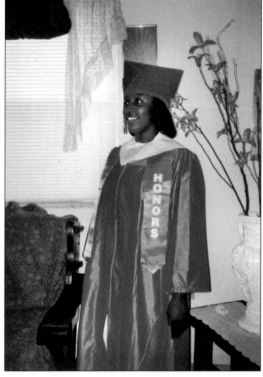

Ronteryl Black is a 1996 honor graduate of Springstead High School. Ronteryl played a vital role in the formation of the local McKnight Achievers Society, a community-based honors program that motivates minority students in grades 4 through 12 to pursue academic excellence.

Blanche Cambric unsuccessfully ran for a school board seat in the early 1970s after the Black Students' Walkout at Hernando High School. The walkout occurred because of cultural insensitivity. There were no black administrators in 1969, and the band played the song "Dixie." Blacks found the song to be offensive. (Courtesy Sarah Stewart.)

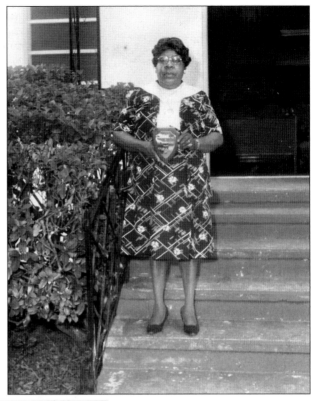

Jane Wright Robinson is the director of Head Start for Dade County, Florida. She graduated from Moton High School in 1968. (Courtesy Eloise Wright.)

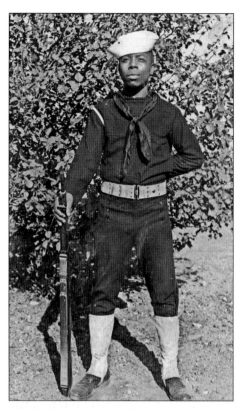

Willie Mitchell stands at parade rest at the naval compound at Great Lakes, Illinois, when he was around 17 years old. He is 78 years old now. He reports that he was knocked from his bed from the Port Chicago Mutiny in California. Port Chicago, California, was the naval ammunition depot located near San Francisco Bay. Black sailors moved the ammunition by hand, including bombs, without proper training. An explosion occurred on July 17, 1944. Three hundred and twenty sailors were killed; 202 were black. A cause for the explosion was never determined. (Courtesy Willie Mitchell.)

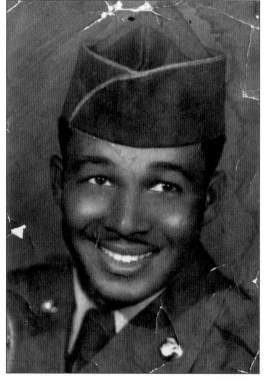

Willie James Brooks is a former deputy sheriff and retired from the Hernando County School System. He became a deputy sheriff in 1964 and served until 1971. He served in the U.S. Army in Europe from 1951 to 1954. (Courtesy Willie James Brooks.)

Four

BLACK PATRIOTS

Willie McGhee was killed in the
Korean War in 1951. Willie is believed
to be the first black from Hernando
County who was killed in combat.

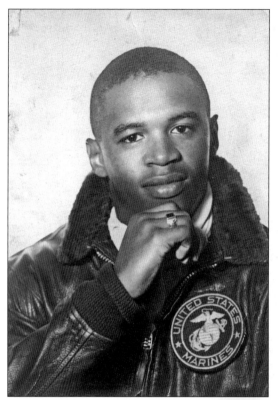

Hercules "Billy" Moore graduated from Moton High School in 1967. As a student, he lettered in football, basketball, and baseball. He even found time to coach Little League baseball and serve as a lifeguard as an employee of the federally funded Neighborhood Youth Corps. Billy was offered several scholarships but joined the Marine Corps shortly after his high school graduation and completed his boot camp at Paris Island, South Carolina. Billy married the former Joann Kincade, and they are the parents of a daughter. Billy was killed in Vietnam in 1968. (Courtesy Lillie Moore.)

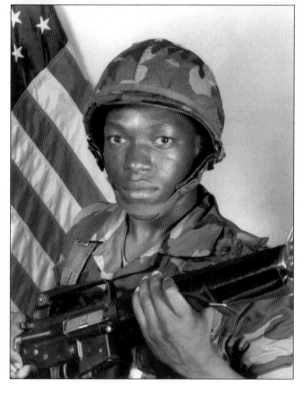

Army Sp4c Thomas Vernon Smith was killed in a plane crash over Lockerbrie, Scotland, in 1986 when he was returning from a peacekeeping mission in Israel. His home base was Fort Campbell, Kentucky. He was 21 years old. He graduated from Hernando Adult Education. (Courtesy Dorothy Smith.)

Capt. Lester Brown Jr., U.S. Army, served a tour in Germany before taking a job in corporate America. Lester is a 1974 graduate of Hernando High School and excelled athletically. Lester worked for Lender's Bagels as operation manager in Matton, Illinois. He is now working in New York. (Courtesy Ella Mae McAuley.)

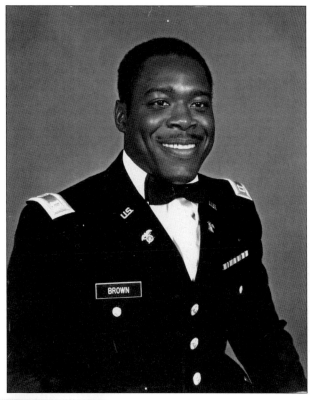

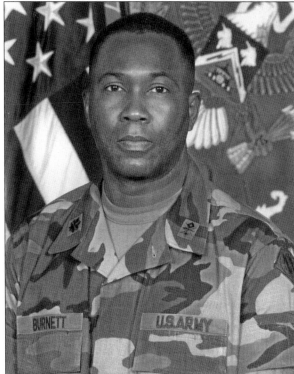

Peter Burnett of the U.S. Army has risen to the rank of colonel. He graduated from the University of Florida ROTC program after serving a one-term enlistment. Burnett received his commission in the early 1980s. He is a graduate of the War College. He is married to the former Dorothy Blount, and they have two daughters. He is a major in this photograph. (Courtesy Louise Williams.)

Pvt. Clarence Walker served most of his duty in Europe. He was a Korean War–era veteran, but he did not serve in Korea. He taught agriculture at Moton High School. (Courtesy Naomi Walker.)

Pvt. Wyet Douglas was drafted by the U.S. Army and served during World War II in Europe. He retired from Camp, a local rock mine. Wyet was a charter member of the Frederick Kelly Elk Lodge #1270 and a member of the Church of the Living God. He enjoyed fishing. (Courtesy Freddie Douglas.)

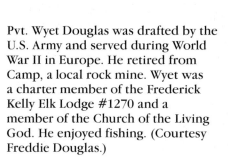

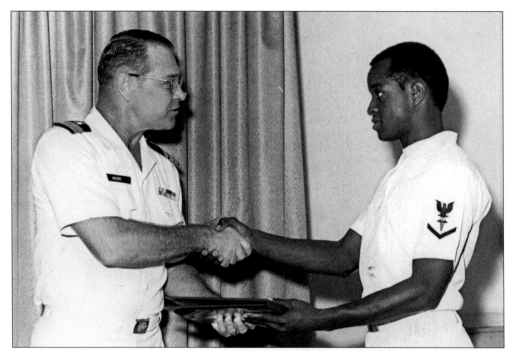

PO3 Dale Bennett (now Imani D. Asukile) receives promotion from Commander Moore at the Naval Regional Medical Center in Okinawa, Japan, in 1978. During his tenure in Japan, he coached a championship basketball team and coordinated the medical center's first observance of the Dr. Martin Luther King Jr. holiday years before it officially became a holiday.

Raymond Lynch served in the U.S. Army during the Korean War. He migrated to Michigan in the 1960s, and that is where he died. (Courtesy Freddie Douglas.)

Haley Lynch Jr. was a World War II veteran who served in Japan. He was a carpenter and a member of the Freewill Baptist Church. (Courtesy Freddie Douglas.)

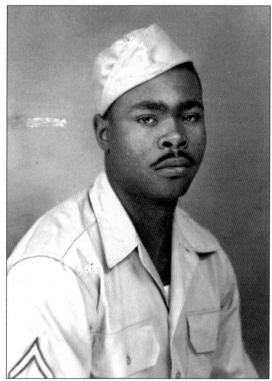

Jerry Dean Ingram is a World War II veteran who served in Germany. He worked at Portland Cement in Tampa for 31 years. (Courtesy Mae Alice Ingram.)

Saul Wright, U.S. Marine Corps, is a Vietnam-era veteran. He graduated from high school in 1967. Saul worked for Southern Bell Company after his military service. He now works in law enforcement and lives in South Florida. (Courtesy Eloise Wright.)

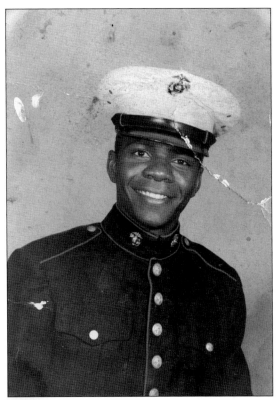

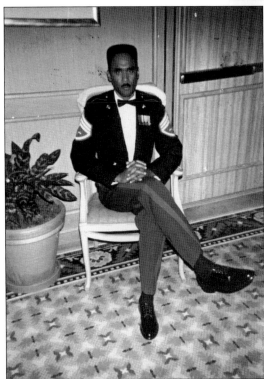

SSgt. Gerald Redfield is dressed in his U.S. Marine Corps dress-blue uniform. Gerald graduated from Moton High in 1968. He served on the West Coast in California and in Okinawa, Japan. (Courtesy Johnnie Redfield.)

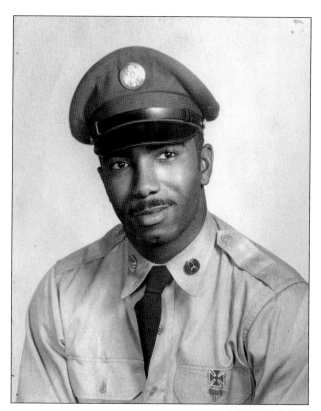

Leon Dunlap Lewis is a Vietnam-era veteran. He graduated from Moton High School in 1960. (Courtesy Mary Rofile.)

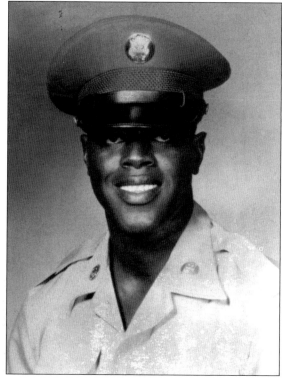

Elijah John Bennett served one tour of duty in Vietnam. He is a member of the Moton High class of 1961. Elijah, a disabled veteran, served for two years. He completed basic training at Fort Benning, California, and jungle training at Fort Polk, Louisiana. (Courtesy Elijah Bennett.)

Harold Johnson was a member of the Moton High School class of 1966. He served in the army and was stationed in Japan. He died in a tragic car accident on December 25, 1971. (Courtesy Gwendolyn Lawson.)

PFC Howard Johnson of the U.S. Army is a Vietnam-era veteran. He was drafted and served one tour of duty. Howard was stationed at Camp Casey in Korea. He graduated from Moton High School in 1964. Howard is a licensed practical nurse.

Andrew Williams of the U.S. Air Force served two terms in Vietnam. He graduated from Moton High in 1966.

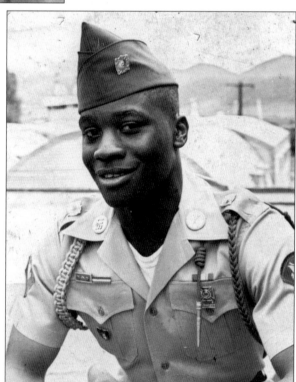

Sp4c George P. Thomas is a Vietnam-era veteran. He is a member of the Moton High School class of 1966.

U.S. Army draftee Frank Maner is a Vietnam veteran. Frank served two years of active duty, four in the reserve, and eight in the National Guard. He works for the Hernando County School Board. Frank used the GI Bill to earn air conditioning and refrigeration credentials. (Courtesy Frank Maner.)

Sp5c Galvin Fagin III was killed in a car accident while serving duty at Scofield Base in Hawaii in 1981. (Courtesy Frank Maner.)

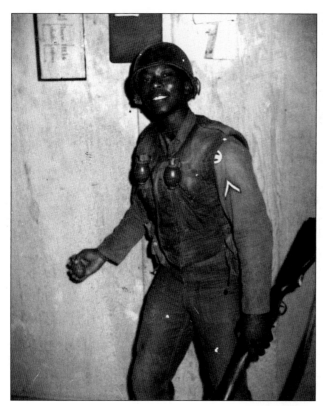

Arthur Gates is a Vietnam veteran. He served one tour of duty in the war. He graduated from Moton High in 1963. (Courtesy Sally Gates Washington.)

Jacqueline Lawson of the U.S. Air Force is shown here. She was one of the first females to retire from the armed services. Jackie graduated from Hernando High School in 1970. (Courtesy Sillar Lawson.)

SFC Earl Wright Jr. of the U.S. Marine Corps receives recognition from a commanding officer at Camp Pendleton in California. He served for more than 20 years. Earl was a member of the Moton High School class of 1960. (Courtesy Eloise Wright.)

Jerry Bell Jr., Hernando High School class of 1995, served in Bosnia, Germany, Cosovo, Iraq, and more. He is using the GI Bill to continue his education. (Courtesy Rosa Bell.)

Cadet Marlin Greene was one of the first blacks from Hernando County to attend one of the prestigious military academies. Marlin attended the U.S. Naval Academy in Annapolis, Maryland. He withdrew from the academy and completed his education at Florida State University, earning a juris doctorate. He was a member of Florida State University's first National College Football championship team in 1993. (Courtesy Mary Cason.)

Jermaine Greene (number 42) played on Florida State University's National Championship team in 1993. His brother, Marlin, played on the same team. Jermaine graduated from Hernando High School. (Courtesy Mary Cason.)

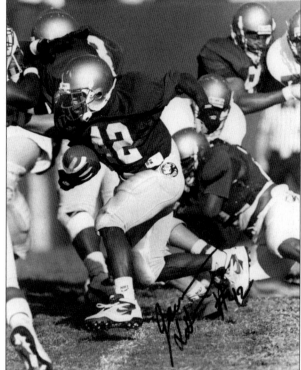

Five

ATHLETICS

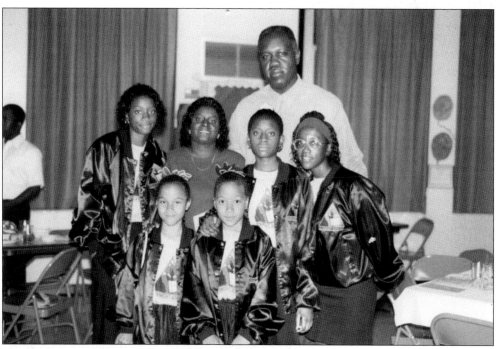

Maulty Moore was a member of both of the Miami Dolphins National Football League championship teams. The Dolphins won Super Bowl VII and VIII. The Dolphins remain the only team in the NFL to go undefeated. In 1972, the Dolphins were 17-0. Maulty was a special team player and a substitute defensive lineman. He played in Super Bowl XI also, but his team lost to the Cowboys. He graduated from Moton High School in 1964 and Bethune-Cookman College in Daytona Beach, Florida. Maulty is shown above with, from left to right, (first row) Nina and Sheena Johnson; (second row) Jerica Greene, Janice Greene, Janelle Greene, and Ronteryl Black..

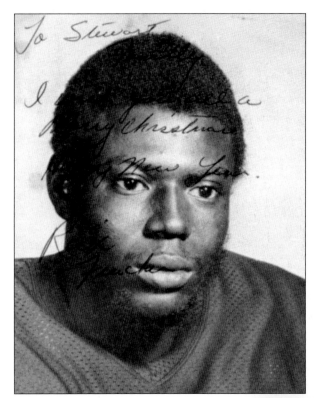

Ricky Feacher played for the Cleveland Browns in the National Football League (NFL) for nine years. He was a wide receiver. Feacher served as a Browns scout and the director of player relations after his career ended in 1984. He graduated from Hernando High School in 1972, when he won Best Athlete honors and Best Offensive Player in basketball. He earned his bachelor's degree from Mississippi Valley State College. Feacher now works as a loan consultant for American Midwest Mortgage. (Courtesy Sarah Stewart.)

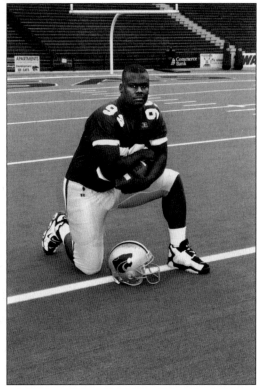

Andrew Timmons is a Hernando High graduate who played football at the University of Kansas. His brother, Carlos, played for Eastern Kentucky University. (Courtesy Diane Huggins.)

90

Jerome Brown was a dominant defensive lineman at the University of Miami from 1983 to 1986. He won the following honors: Consensus All-American, finalist for the 1986 Outland Trophy, and the 1986 Lombardi Award. Brown was drafted by the Philadelphia Eagles in the first round in 1986. He was named to two Pro-Bowls before his life ended in a tragic car accident in 1992. (Courtesy Opehila Brown.)

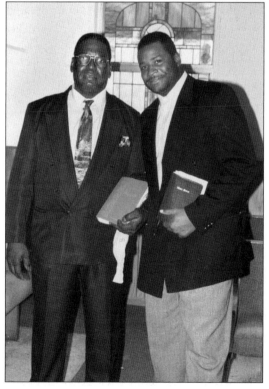

Willie Brown and all-pro receiver Keith Jackson shared a spiritual moment at the Josephine Street Church of the Living God in Brooksville. Jackson was a friend and former teammate of Willie's son, Jerome Brown, who was killed in a car accident. Jackson was a tight end for the Green Bay Packers on the Super Bowl XXXI championship team in 1996. He was a frequent participant in the Jerome Brown Football Camp and was one of many individuals instrumental in getting the Jerome Brown Community Center built.

Dwayne Mobley played fullback on the University of Florida Gators National College Football Championship team in 1996. Dwayne holds several rushing records at Hernando High School, his alma mater. He was a high school All-American. (Courtesy Brenda Mobley.)

Olympian John Capel participated in the 2000 Summer Olympics in Sidney, Australia, as a sprinter. Capel was the favorite for the gold, but he was late getting out of the blocks. He did not qualify for the 2004 Summer Olympics in Athens, Greece. He played football at the University of Florida and had a brief stint in the NFL. He also ran track and played football at Hernando High School, where he graduated in 1998. John's career highlights include being 2003 World Outdoor 200 meter champion and 4-by-100 meter relay gold medalist; 2000 Olympic Trials 200 meter champion; 2003 Indoor 200 meter champion, and 1999 NCAA Outdoor 200 meter champion. (Courtesy Virginia Capel.)

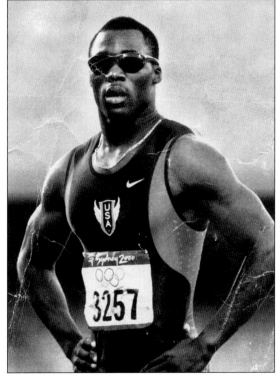

Jefferson Pittman Inmon, Hernando High School class of 1969, earned a scholarship to play football at North Carolina Central University (NCCU). He earned many honors: All-MEAC (Mideastern Athletic Conference), MEAC Player of the Year, and *Pittsburgh Courier* All-American. He was drafted by the Los Angeles Rams. Inmon earned his bachelor's and master's degrees. He was inducted into the NCCU Athletic Hall of Fame in 1985. (Courtesy Beverly Trenton.)

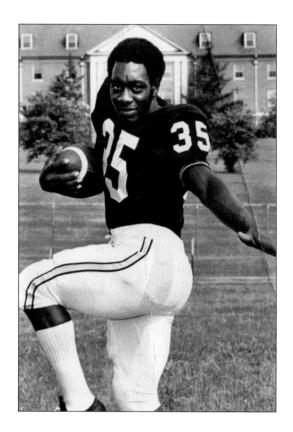

Benny "Butch" Hodges was co-captain of Moton High School's 1958 Mid-8 Atlantic Conference football championship team. The defensive back was inducted into the Football Hall of Fame at Elizabeth City State University in North Carolina in 1983. From 1960 to 1963, he served in the U.S. Army, 82nd Airborne Division. Hodges retired in 1999 as warden of the St. Mary's County, Maryland, Adult Detention Facility. (Courtesy Howard Johnson.)

Coach Edward Chester was Springstead High School's first football coach. He was a member of Moton High School championship football team. He attended college and played football at St. Augustine College in Raleigh, North Carolina, where he earned his bachelor's degree. Ed recently retired from Springstead High School as an assistant principal.

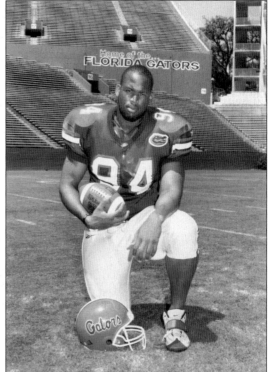

Ed Chester was a University of Florida defensive lineman. He graduated from Springstead High School. A knee injury destroyed his dreams of playing in the NFL. (Courtesy Ethel Chester.)

Daniel Oliver (31) played for the Florida Agriculture and Mechanical University Black College Championship team in 1977 and Division I National Championship team 1978. Dan is employed by the U.S. Department of Agriculture, Natural Resources Conservation Services as a district conservationist serving Pasco and Hernando Counties. He graduated from Leesburg High. This photo was taken in Tampa Stadium in 1979.

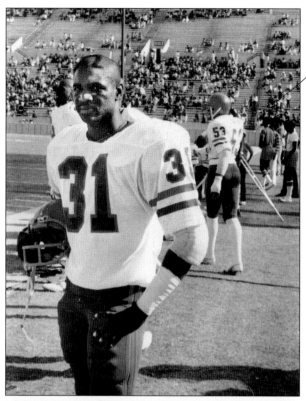

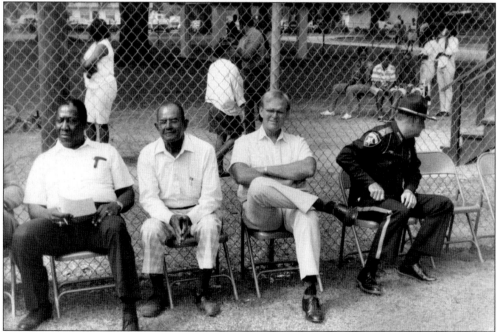

From left to right, Bishop Ted Brown, Deacon Harnell Clark, Pat Fagin (director of Parks and Recreation), and a representative from the Sheriff's Department look in during one of Kennedy Park Little League's Opening Day ceremonies.

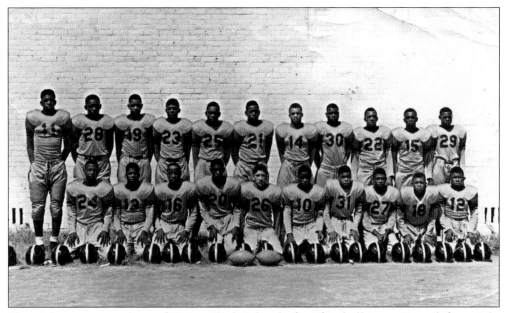

Shown here are members of Moton High School's first football team. From left to right are (kneeling) Curtis Washington, Andrew Williams, Frank Spears, Tommy Bush, James Perkins, Willie Stephens, Marion Washington, Wilbur Bush, Willie Jones, and Cornelius Lawson; (standing) Willie Rip Richardson, George Fribley, unidentified, James Washington, Jimmy Inmon, Joe Brown, Leonard Inmon, Anthony Timmons, Jeff McGill, Henderson Stephens, and Herbert Stanley. (Courtesy Bennie Clarke.)

Stephanie Richardson played shortstop for the community softball team, the Jets. She is considered to be one of the greatest female athletes in the county's history of female sports. She possessed speed, quickness, power, and leadership. She played before Hernando County School Board started athletics for girls.

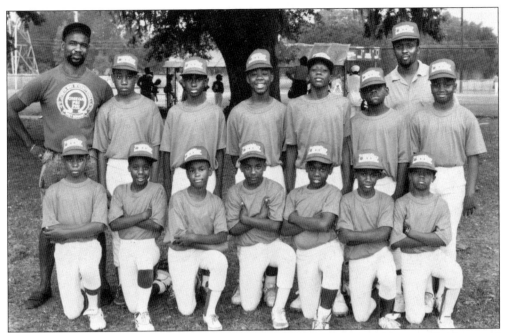

Kennedy Park Little League Baseball is one of the few black-managed nationally chartered leagues in rural Florida. The photograph was taken in the early 1990s. Shown from left to right are (kneeling) Travis Delaine, Corey Taylor, Ozzie Whitten, Brian Sanders, Joey Brown, Stephen Cassell, and Henry Waddy; (standing) Coach Daniel Oliver, two unidentified, Desmond Nathan, Clarence Adams, Jamal Williams, Christopher Daley, and Coach Raymond Knight.

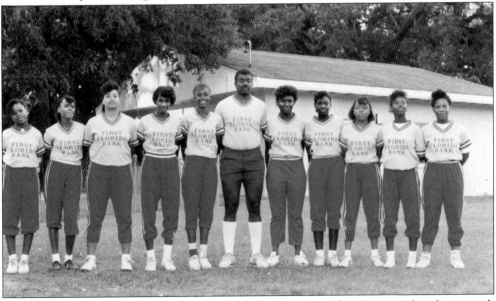

Shown here are members of a Kennedy Park senior girls' softball team. The photograph was taken in the late 1980s. Included here are Connie Townsend, Sharee Scrivens, Debbie ?, ? Golden, Demetrius Holmes, Tommy Hall, Shanetra McCollum, Kimberly Harris, Lashwan Johnson, ? Johnson, and Bonnie Townsend.

Capt. Larry Wright was a Baton Rouge, Louisiana, law enforcement captain. He graduated from the Federal Bureau of Investigation Academy in Quantico, Virginia. Larry was a member of the Leopards football team and was co-captain in 1970. He graduated from Hernando High School in 1971. (Courtesy Eloise Wright.)

Curtis Bunch owns a car dealership in Pennsylvania. He graduated from Hernando High School in 1974. Curtis played football at Albany State College in Georgia. He also played professional football with the Philadelphia Eagles and the Tampa Bay Bandits. (Courtesy Eloise Wright.)

Six

CAREERS AND PROFESSIONS

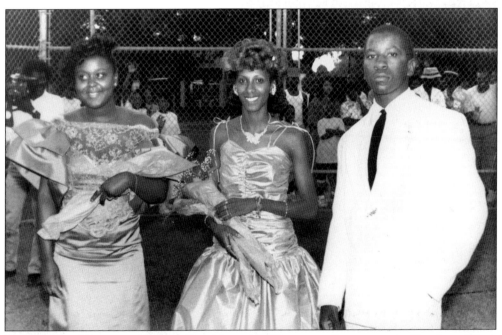

Former May Day queen Jacqueline Maner (left) passes the crown to Monique West. Gregory Woods is Monique's escort. May Day, a spring festival held on the first Saturday in June, is sponsored by the Hernando County Professional Organization. The event was a very popular school-sponsored event prior to desegregation. Hernando County Professional Organization re-enacted May Day in the 1980s at Kennedy Park. The event consisted of plaiting the maypole, square dancing, singing, and other activities.

Luther Cason is a former mayor of the city of Brooksville, Florida. He is the owner and director of Community Funeral Services and owns several other businesses. (Courtesy City of Brooksville.)

Hernando County Supervisor of Elections Annie D. Williams was first elected in 2000 and ran unopposed in 2004. She has worked in the office since 1973. (Courtesy Hernando County Government.)

Councilman Frankie Burnett was elected to the Brooksville City Council in 2004. He also served as president of the Hernando County Branch NAACP, Habitat for Humanity, and other organizations.

JoAnne Munford works for the City of Brooksville as a recreation leader at the Jerome Brown Community Center. JoAnne has a long history of service to the community, and she has been recognized both locally and nationally for her service. She is a recipient of the Lifetime Television Lifetime Achievement Award for dedication and effort as a "hometown hero." In 2004, she was a finalist for the Community Involvement Program of the Year category in the Stevie Award for Women Entrepreneurs, which recognizes women in small business. JoAnne was director of Americorps, President Clinton's version of the Peace Corps in the 1990s.

Thomas White holds a youngster in his arms outside of Mount Pilgrim Freewill Baptist Church. Thomas operated a dry cleaners (below) on Josephine Street for years. Dry cleaning skills were common in the White family. (Courtesy Bennie Clarke.)

Thomas White Cleaners (left) and the Stewart Hotel were popular business during the 1960s. The dry cleaning business closed in the 1970s.

Carpenter Fred Williams built and renovated many local homes. (Courtesy Fred Williams Jr.)

Mary Alice Rofile, born in 1915 in Sylvania, Georgia, will celebrate her 91st birthday in 2006. She was a domestic worker when she worked doing laundry, and she specialized in ironing doilies. She was the neighborhood baker. She fed the children in the community a slice of cake every Sunday. Her specialty was hot cakes, cornbread batter cooked like a pancake.

James Yant is a State Farm agent in Spring Hill, Florida. James worked for the public school system and Pasco-Hernando Community College.

Deputy Sheriff Lee Andrew Lawson is photographed with his dog, Rusty. Lee and Willie James Brooks were the first blacks to serve in law enforcement since Reconstruction. Lawson's career started in the mid-1960s. Lee and Brooks worked part-time. (Courtesy Willie James Brooks.)

Deputy Sheriff and School Resource Officer Tommy Harris is a Springstead High School graduate. He commenced his law enforcement career in 1986 as a jailer. He was sponsored by former sheriff Thomas Mylander. (Courtesy Isabel Harris.)

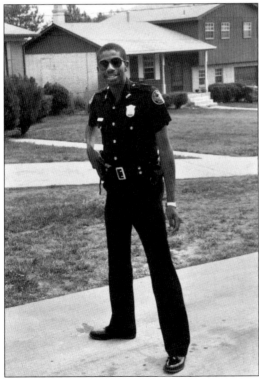

Gary Wright is a police officer in Atlanta, Georgia. He was a member of Mayor Maynard Jackson's security team. (Courtesy Eloise Wright.)

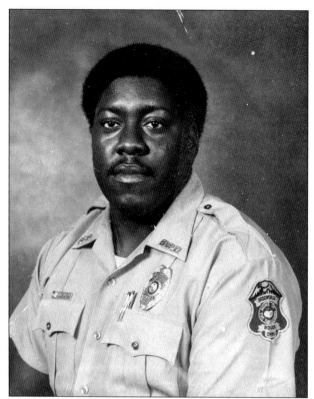

Lee A. Inmon served as a police officer for the city of Brooksville in the late 1970s. He is a former pastor of Shiloh Missionary Baptist Church and currently works for the state in security. (Courtesy Lillie Neal.)

Carnes Lawson was the first black American city of Brooksville patrolman. He served in the 1970s. He also was the pastor at Mount Zion AME Church. He died in February 1996. (Courtesy Sarah Stewart.)

Ivory Gray is the director of the Mid-Florida Community Services Head Start Program, which serves Hernando and Sumter Counties. (Courtesy Head Start.)

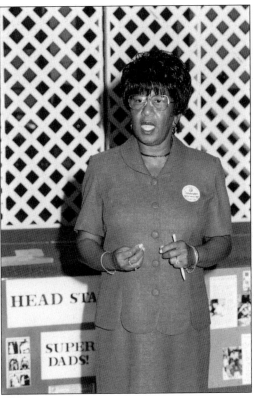

Cassandra Clayton is the co-owner of Happy Land Daycare, Inc. Cassandra graduated from Pasco-Hernando Community College and since has earned both her bachelor's and her master's degrees.

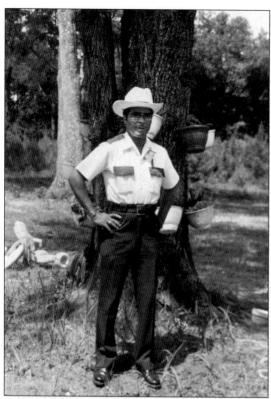

James Robert "Bobby" Clark is a retired Florida Department of Corrections employee. (Courtesy Phyllis Hall.)

Elise Carmichael was the seamstress for Lingle's Department Store. (Courtesy Johnnie Redfield.)

Thomas Roberts was a longtime
employee with Deltona Corporation
in Spring Hill. The company
recently merged with Hernando
County Utilities. Thomas started
work with the company in the
1960s when Spring Hill was a small
budding community of less than
10,000 people.

Jimmy W. Brooks is a longtime employee of Florida Power Corporation.

Gwendolyn Lawson became an operator for Southern Bell in the 1970s. She recently retired from Atlanta and returned to Hernando County to sell real estate.

Theater's or Jitterbug was a popular juke joint during the 1950s, 1960s, and 1970s. The freezes that killed the local citrus industry were responsible for its demise, as it was a favorite of transients who came to town during orange season.

Howard's Bar-B-Que is located on a strip along Martin Luther King, Jr. Drive. The building opened in the late 1950s as a pool hall and café. When the owner died in 1966, Howard purchased the businesses and operated them successfully until the 1980s killer freezes.

William Buddy Delaine was one of Mrs. Velma Lykes personal chauffeurs. He retired from the railroad. His brother, James, also worked for Mrs. Lykes. (Courtesy Martha Delaine.)

Fred's General Store closed in 2004. The building was built in the 1950s and served as a bar during the height of the citrus era. Fred Fletcher also operated a barbershop next to the store and owned rental property.

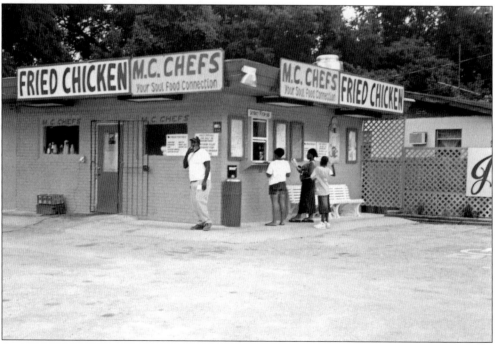

M. C. Chefs is a favorite hangout for breakfast and other meals. The "C" stands for Christopher, who owns the cookery. Mr. C. caters many wedding receptions, reunions, and other social events. He even fries the chicken that is served at most funeral repasts.

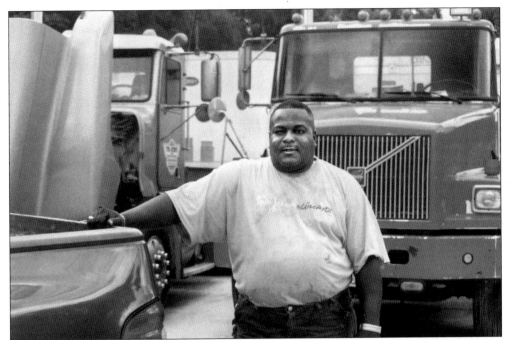

Charlie Brown Trucking Company is one of the few black-owned truck companies in the area. Two of Brown's trucks are in the background, and his hand rests on his pickup truck.

Richard Howell is a member of Moton High School class of 1962, where he excelled academically and in football. Richard served in the U.S. Air Force from 1962 to 1966. Prior to returning home to Brooksville in the late 1980s, Richard lived in the Washington, D.C., and Alexandria, Virginia, areas. He is a computer technology consultant. He is a tireless advocate for social, economic, and environmental justice for the south Brooksville community.

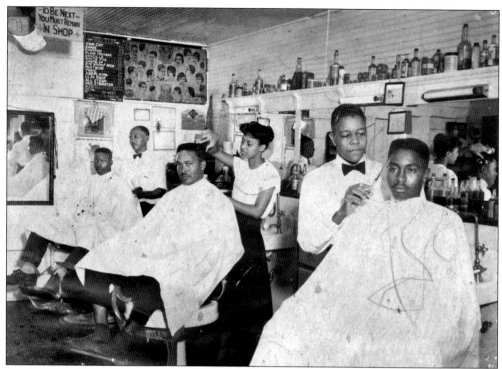

Samuel Newton (second from right) gives a precise haircut to an unidentified customer in his Orlando barbershop. (Courtesy Bernice Newton.)

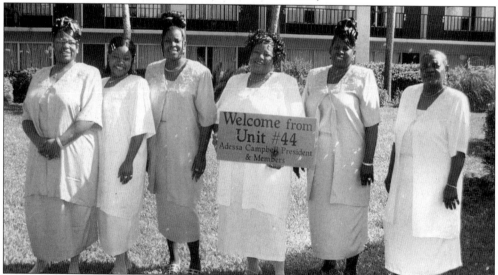

Shown from left to right are the following members of Orange Blossom Cosmetologists Unit #44 from Dade City, Brooksville, and Bushnell: Aretha Conley, Vanessa Campbell, unidentified, Odessa Campbell, Lillian Hunter, and Mary Johnson. Mary works from her home in Brooksville and is one of the senior hairstylists in the community. She is also active with the Community Gospel Choir in Brooksville. Mary and Lillian earned doctorate degrees in cosmetology from Bronner Brother Cosmetics in Atlanta, Georgia. Hair styling is a lucrative business for blacks. (Courtesy Mary Johnson.)

Seven

SOCIETIES, CLUBS, SOCIAL ORGANIZATIONS, AND FUNERALS

Prince Hall Masonic Lodge #97 was one of the primary outlets for teenagers during the 1960 and 1970s. It was a community center that held dances for teens. The Lodge was organized in 1945, and many prominent men in the community were members. The baby boomers did not make the commitment to this institution, and therefore it suffers. The building now stands vacant.

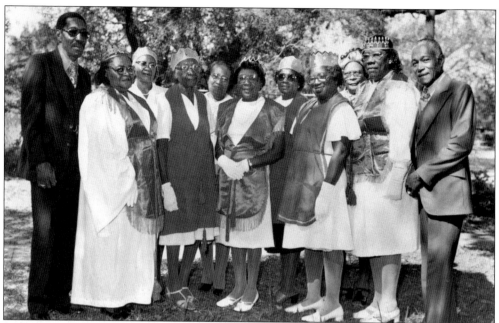

Heroines of Jericho, an aid society that was formed to assist people in times of hardship, provides social activities. Locals identified here include James V. Hall (far left) and Mae Alice Ingram (back center, with sunglasses). (Courtesy Mae Alice Ingram.)

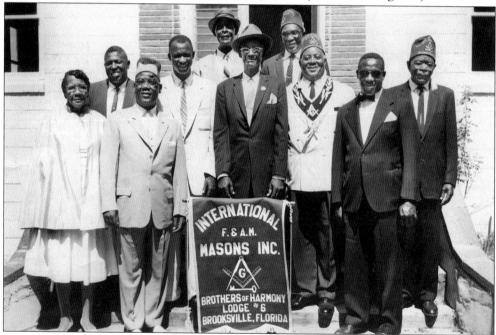

Photographed here are members of the International Masonic Lodge #6. From left to right, they are (front row) Gracie Newton, Alex Holmes, Spencer Duckett, and Harry Mobley; (second row) Mallie Washington, James H. Hall, Redden "Red" Hasty, and Andrew Newton; (third row) Willie Jones and Willie McGhee. (Courtesy Arthur Thomas Jr. and Bernice Newton.)

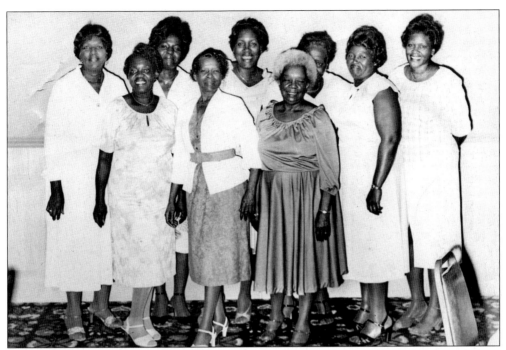

The following members of the Jolly Christmas Club, a social club, are pictured from left to right in the early 1980s: Mildred Sims, Mary Johnson, Annie Mae Walker, Levy Johnson, Mae Pearl Neal, Clyde Clark, Barbie J. Hall, Lillie Moore, and Hattie Byrd. (Courtesy Mildred Sims.)

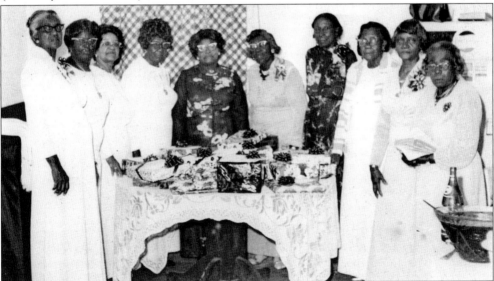

Members of the Widows' Club in the early 1980s are, from left to right, Lavern Washington, Cora Spencer, Carrie Duckett, Rosa Harris, Neilia Mills, Pinkie Roberts, Maude Brown, Gracie Newton, Ruth Que, and Beatrice Riggins. Idella Washington and Beatrice Greene are not pictured. All are deceased except for Que and Greene. The Widows' Club was a support group composed of widows. The group held regular meetings where they engaged in conversation, ate snacks, and had fun. (Courtesy Ann Morrell.)

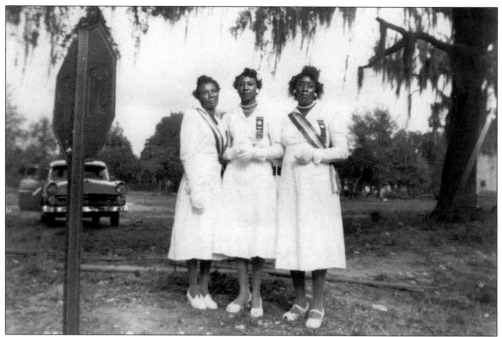

Members of the Eastern Stars, from left to right, are Sarah Stewart, Edna Willis, and Vera Chester. The Eastern Stars is a Masonic organization that aided members during hardships, such as deaths and illnesses. (Courtesy Sarah Stewart.)

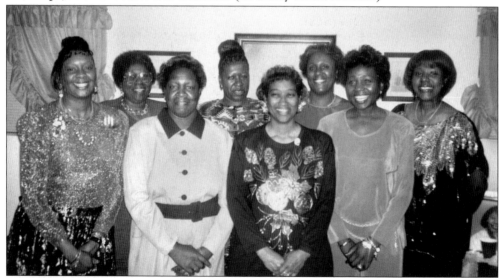

Interested Women in Various Endeavors of Society (IWVES) are pictured here in the late 1980s. They are, from left to right, (first row) Beverly Trenton, Bonnie Inmon, and Christene Yant; (second row) Cheryl Scrivens, Evenlyn Washington, Josephine Roberts, Madilyn Holmes, and Brenda Cason. Jessie Eleby is not pictured. The IWVES is a social club for married women that formed in the late 1970s for acquaintances purposes as many of the ladies were new to the community. They shop, attend concerts, and travel together. One of their most popular activities was attending the Ebony Fashion Show in Tampa annually, and the group annually attends the Essence Festival in New Orleans.

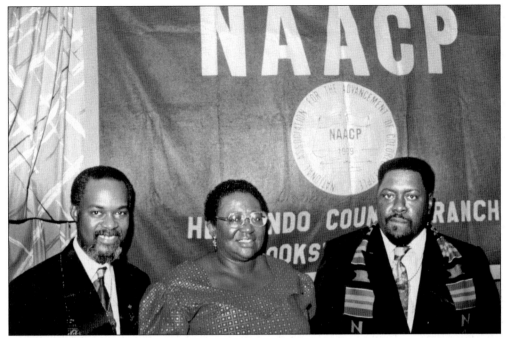

National NAACP Acting Executive Director and CEO Earl Shinhoster (left), branch founder Hazel Land (center), and president Lee Inmon rejoice after a successful Freedom Fund Banquet fund-raiser. Shinhoster was the banquet speaker. The banquet, whose theme was "Passing the Torch . . . Preparing for a Better Tomorrow," was held on Saturday, October 9, 1993, at VFW Post 8681.

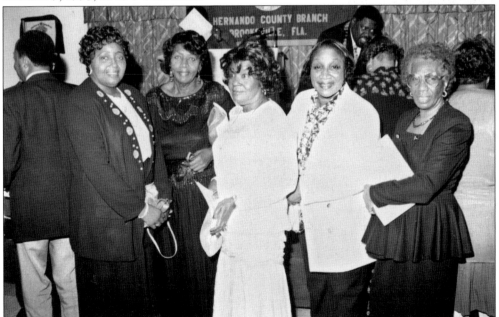

These ladies attended the same NAACP Freedom Fund Banquet. They are, from left to right, Rosetta Perry, Mildred Sims, Flora Jones, Martha Delaine, and Eloise Wright. This is a popular social event.

Rochelle Gonzales, a World War II veteran who served in Europe, was a charter member of the Prince Hall Masonic #97 and president of the Grand Lodge Pallbearers Order when it was chartered in 1940. The Grand Lodge Pallbearers Order provided burial assistance to family members of the deceased. Insurance options were limited to blacks until the early 1960s.

Pioneer Mose McCriminger was one of the charter members of the Frederick Kelly Elk Lodge #1270. Mose was a supporter of programs for the youth in the community. He attended Little League baseball games until his health started declining.

Eugene "Gene" Redding (left) and Henry Harris enjoy the moment at the Elks Lodge. Gene played a critical role in the development of Cliff's Septic Company. He was a very skillful employee and hired many black men in the 1970s and 1980s. Henry Harris was a member of the Lodge and a retired school board employee.

Ira Floyd, former Daughter Ruler Kelly's Temple 1004 and Grand Exalted Ruler, and Hon. Dr. Donald P. Wilson, share memories at the local lodge's 50th anniversary in 1998. Floyd has received many awards and recognition since her retirement as a home economics teacher.

Bridgett Taylor published a weekly newspaper, *Progress*, that reported on news in the black community in the 1980s. The paper lasted about a year. Here Bridgett addresses the Martin Luther King Jr. Day crowd in 1989. In memory of all of the people who gave their lives during the civil rights movement, the NAACP sponsored a march from Moton High School to the courthouse. (Courtesy Henry Wright.)

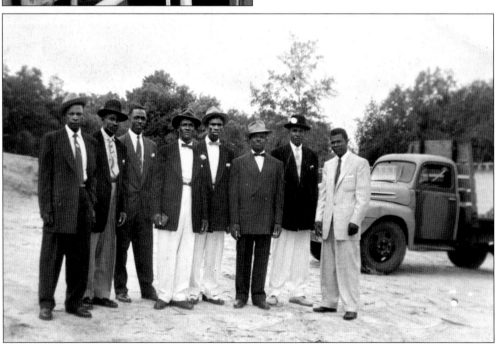

Jamaican men were recruited to Brooksville to pick oranges. A camp was built behind the Exchange Packing House east of the train tracks on Martin Luther King, Jr. Drive. Many of the men eventually secured work at one of the mines.

John Wallace served as president of the NAACP twice and owns several businesses. He is an entrepreneur and a member of the Moton High School class of 1958. A disabled veteran, John served in the Air Force.

Lorenzo Hamilton served for more than 30 years in the Hernando County School System as teacher, coach, and administrator. His service to the community went beyond the call of paid career duties and responsibilities. Some of his contributions include coordinating Hernando High School's first Black History Month Observance and serving as director of Kennedy Park Little League, Upward Bound Coordinator, state champion coach, and charter member of the Black Educators Caucus and Hernando County Professional Organization. The center was named in his honor in recognition of his service.

One-horse wagons were commonly used for transportation and work during the first half of the 20th century.

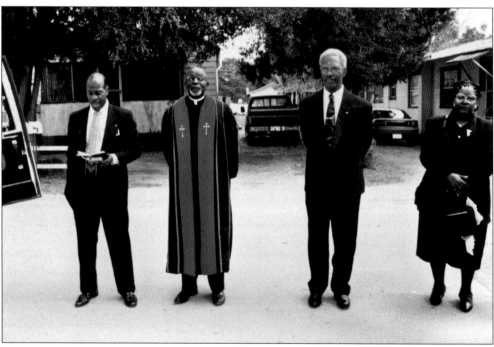

From left to right, Rev. Cecil Hubbert, Rev. W. A. Haley, Rev. Burdell Strickland, and Rev. Irene Wells lead the funeral recession for Leo Goodson at Allen Temple African Methodist Episcopal Church on Twigg Street. Reverend Haley delivered the eulogy.

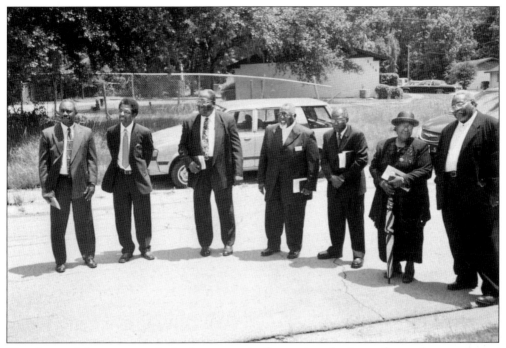

Members of the community's clergy are in formation during a funeral recession at Ebenezer Baptist Church. They are, from left to right, Vinson Parnell, Herman Scrivens, Theodore Brown Sr., David Swackard Sr., Wilbur Bush, Irene Wells, and David Stewart Jr. This was Beverly Inmon Trenton's funeral in June 2005.

Erica (left) and Dianna Butts join the Wright family for the funeral repast of Earl Wright at Moton High cafeteria. They are close friends of the Wrights and were present during this time of sorrow to comfort the family.

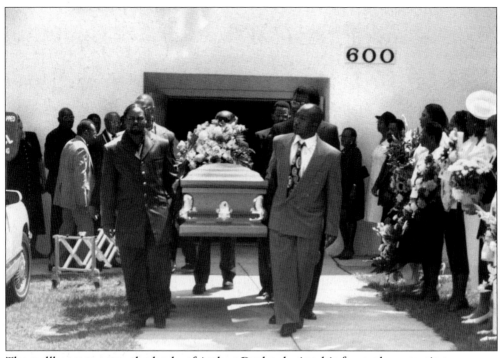

The pallbearers carry the body of Arthur Drake during his funeral procession.

Walter Taylor Sr. was a World War I veteran. He lived in the Shady Rest community and donated the land in the early 1940s so that First Baptist Church at Shady Rest could be built. Walter was a fishing guide at Bayport on the Gulf of Mexico in Hernando County. He assisted the tourists with lodging and where and how to cast their lines. He also worked at Murphy's Drugstore.

WELLFLEET

Daniel Lombardo